LOST
CARSON CITY

PETER B. MIRES

Published by The History Press
Charleston, SC
www.historypress.com

Copyright © 2018 by Peter B. Mires
All rights reserved

First published 2018

Manufactured in the United States

ISBN 9781467138819

Library of Congress Control Number: 2018932116

Notice: The information in this book is true and complete to the best of our knowledge. It is offered without guarantee on the part of the author or The History Press. The author and The History Press disclaim all liability in connection with the use of this book.

All rights reserved. No part of this book may be reproduced or transmitted in any form whatsoever without prior written permission from the publisher except in the case of brief quotations embodied in critical articles and reviews.

*This book is dedicated to Samuel Langhorne Clemens,
who became Mark Twain in Carson City.*

CONTENTS

Acknowledgements 7
Introduction 9

I. Carson City Begins
 Sagebrush to State Capital 15
 Sandstone, Lumber and Brick 25

II. Places
 East Meets West in Chinatown 35
 Carson's Red-Light District 39
 Parks and Recreation 45

III. Buildings
 Worth a Mint 55
 Arts and Entertainment 60

IV. People
 Carson's First People: The Washoe 69
 From Great Britain to the Great Basin 77
 Literary Carson City 83
 The Teacher, the Inventor and the Scientist 90

V. Events
 Carson City Has Its Faults 101
 Nevada Day and Halloween 106

Contents

VI. Corridors
 The Virginia and Truckee Railroad 113
 Pony Express and Lincoln Highway 118
 The Streets of Carson 123
VII. Carson City Continues
 The City-County 131
 The Changing Landscape 134

Epilogue 145
Resources 149
Selected Bibliography 151
Index 155
About the Author 159

ACKNOWLEDGEMENTS

First and foremost, I would like to thank friends and colleagues for their collective assistance and encouragement. They include: Gayle Bowers, ZoAnn Campana, Scott Challman, Sandra Hedicke Clark, Kim Grey, Robin Johnson, Bob Kautz, Jeff Kintop, McAvoy Layne, Anne Leek, Mike Makley, Mike Morley, Gary Noy, Bob Stewart and Peter Van Bemmel. I also thank fellow members of the Lone Mountain Writers Group, as well as Laurie Krill, my talented and energetic editor at The History Press.

I am indebted to a number of libraries and archives and their knowledgeable staff, as well as individuals who offered access to their collections. The people who helped me in my research are legion, but the following individuals went above and beyond the call of duty to help me find just the right photograph: Jim Bertolini, Natacha Faillers, Norma Jean Hesse, Catherine Magee, Liz Moore, Kim Roberts and Cindy Southerland. I also would like to thank the staff of the library at Western Nevada College in Carson City.

Illustrations appearing in this book are attributed to the following sources: Library of Congress; Nevada Historical Society; Nevada State Historic Preservation Office; Nevada State Library and Archives; Norma Jean Hesse; Special Collections Department, University of Nevada–Reno, Libraries; and Southerland Studios.

Finally, I thank the Nevada Historical Society for permission to republish a portion of my article "From Great Britain to the Great Basin: Robert Fulstone and Early Carson City," which first appeared in the *Nevada Historical Society Quarterly* in 1998.

INTRODUCTION

Carson City is not lost in the same sense as the legendary Lost Dutchman's Mine or Fawcett's Lost City of Z. The capital city of the state of Nevada is still very much where it has always been since its founding in 1858. Like any community, however, Carson City has experienced change over time, particularly in what may be called its cultural landscape. *Lost Carson City* is best described as a book-length look at what may not be readily apparent about the city and its hinterland.

Residents and visitors alike know such landmarks as the Nevada State Capitol, the Carson City Mint and the Governor's Mansion. These are iconic components of the city's heritage and identity. All but forgotten, or lost if you prefer, are Carson City's once populous Chinatown, its brothels situated just blocks from the city's center, the busy Virginia and Truckee (V&T) Railroad shops, the French Hotel associated with the Laxalt family and other places around town not necessarily identifiable by map or marker.

Not surprisingly, what has been written about Carson City pales by comparison to its more flamboyant and celebrated neighbor, Virginia City. In this, Nevada's capital city is not alone; look at other states and notice how their capital cities exist in the shadow of greater metropolises: Albany and New York City being a case in point. As the epicenter of the Comstock Lode silver mining frenzy of the 1860s and 1870s, Virginia City got all the attention. The literature surrounding it parallels its importance, and books continue to be written about those halcyon days up on the Comstock.

Introduction

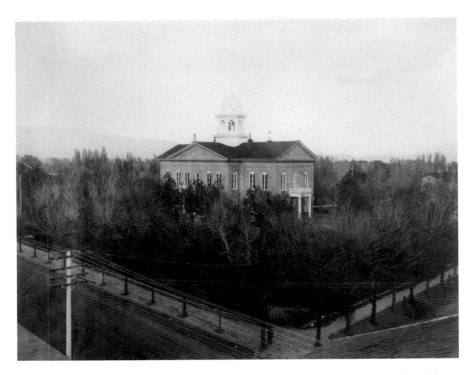

Nevada State Capitol and grounds, looking northeast, circa 1890. *Courtesy of the Nevada State Library and Archives.*

There is a growing body of literature on the history of Carson City, especially since the 2008 sesquicentennial of the city's founding. Books like Richard Moreno's *A Short History of Carson City* (2011) and monographs devoted to specific topics—cemeteries, trains, coins and so forth—attest to a growing interest in the history of Nevada's capital. Most of these works appear in the selected bibliography in the back of this book.

Without question, the most popular part of Carson City is the west side historic district—and for good reason. From downtown Carson Street and immediately to the west, this assemblage of historic buildings exudes a sense of stepping back in time. Many of these homes, businesses, churches and other buildings are well preserved and still in use, and the best way to see them is to follow the Kit Carson Trail, a self-guided tour established by city boosters in 1992.

Less well publicized, however, is the history of Carson City's east side. A partial explanation for this discrepancy is that many of the components of the historic landscape of the east side are simply gone—the V&T Railroad

Introduction

Left: Kit Carson Trail bronze marker embedded in the sidewalk along South Carson Street. *Photograph by the author.*

Below: President Theodore "Teddy" Roosevelt speaking from the front of the state capitol, May 19, 1903. *Courtesy of the Nevada Historical Society.*

Introduction

shops, the old racetrack, Chinatown, the Nevada State Orphan's Home and Charles Friend's observatory. A group calling itself the Carson City Preservation Coalition attempted to draw greater attention to this half of old Carson City by creating the Charles W. Friend Trail in 1999. Like the west side tour, it is self-guided, but it lacks the painted blue line and bronze medallions that blaze the tourist path west of Carson Street.

In a sense, therefore, this book struggles with the same dichotomy: the known and popular versus the less well known and underappreciated. In recent years, historic preservationists and others have reexamined how people view the landscape and why they find it compelling. The consensus is that it is all in the interpretation. A Civil War battlefield like Gettysburg, for example, may appear bucolic and perhaps even ordinary in the absence of historical interpretation. President Abraham Lincoln, however, affixed so powerful an association with that piece of Pennsylvania farmland that its meaning is not lost from one generation to the next. The analogy may be a little overdrawn, but the point is, an empty lot on Carson City's east side or an old house on the west side also has stories to tell. It is all in the interpretation.

Lost Carson City examines aspects of Nevada's capital city from a cultural landscape perspective, which is to say this book is place-oriented. Each chapter has a tangible relationship to the city's historical geography, be that visible or vanished. The latter term, in fact, is especially challenging because nothing is ever really gone as long as people remember what took place where. What was lost may be found.

PART I
CARSON CITY BEGINS

SAGEBRUSH TO STATE CAPITAL

Humans have lived in the land now known as the state of Nevada for millennia, but technically speaking, the historic period begins with a local and regional written record. That record started with the sporadic forays of early explorers who took circuitous routes on foot and horseback across the landscape. When Christopher H. "Kit" Carson (1809–1868) passed through the area in February 1844, the place that would bear his name resembled an ocean of sagebrush.

The intrepid guide and mountain man had joined Lieutenant John C. Frémont of the U.S. Army Corps of Topographical Engineers on several exploration and mapping expeditions into the West, and according to all accounts, the two were inseparable. Frémont said of Kit Carson, "Carson and Truth are one." Author Irving Stone, in his book *Men to Match My Mountains* (1956), noted, "Kit Carson would have guided Frémont to hell and back, had his friend said it must be done." Actually, Carson and Frémont experienced a frozen and frigid landscape instead, crossing the Sierra Nevada in the middle of February on their way to Sutter's Fort in California's Central Valley.

For most of the 1840s and 1850s, Nevada was a place to be traversed, often with considerable difficulty. Immigrants bound for the Pacific coast faced numerous hardships, not the least of which included the parched Great Basin and the daunting Sierra Nevada range. The pace of westward migration quickened throughout the decade of the 1840s, with two notable punctuations: the ill-fated Donner Party (1846) and the discovery of gold

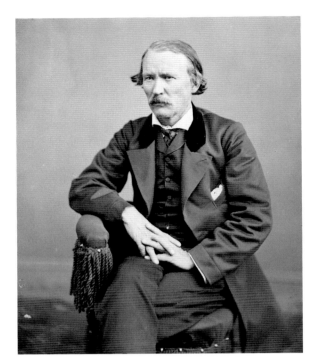

Right: Christopher H. "Kit" Carson (1809–1868). *Courtesy of the Library of Congress.*

Below: Statue of Kit Carson by former Carson City resident Buckeye Blake in the plaza between the Capitol and State Legislative Building. Originally commissioned by Truett and Eula Loftin. Donated to the State of Nevada in 1989. *Photograph by the author.*

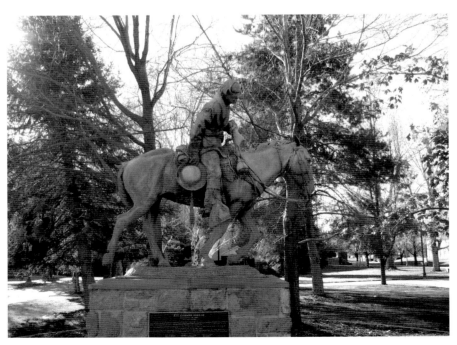

at Sutter's Mill (1848). The former instilled a sense of fear and respect for the mountainous barrier of the Sierra, that last hurdle at the western end of various migrant trails. The latter instilled just the opposite—optimism and excitement almost to the point of reckless abandon—for the so-called argonauts seemed blind to anything but the color gold.

By 1850, when California became a state and Utah a territory, several valleys immediately east of the Sierra Nevada—Carson, Eagle and Washoe—attracted the attention of settlers. These settlers included entrepreneurs who saw opportunity in provisioning immigrants, prospectors in search of mineral wealth comparable to California's Mother Lode and Mormon agriculturalists who wanted to settle what was known as the Carson Valley Mission. The Mormons served an additional function; they were politically in charge of a vast territory that stretched from the Rockies to the Sierras.

Members of the Church of Jesus Christ of Latter-day Saints, or Mormons, who had concluded their exodus to the eastern side of the Great Basin in the late 1840s, decided in 1850 to extend their influence to the extreme western side of newly created Utah Territory. Although cartographers had yet to identify with any precision where Utah Territory ended and the state of California began, they believed, rightly, that the boundary was somewhere in the Sierra Nevada. Mormon Station, present-day Genoa, was established in 1851 in Carson Valley, and over the course of the next six years, Mormon settlers and traders erected a fort, planted gardens, built fences and expanded their land holdings throughout the region.

Mormon political—and to some extent cultural—dominance of the region was not without controversy. Many non-Mormons who had settled in western Utah Territory resented living in what they perceived as a theocratic state. Some called for annexation by California, while others demanded more local government; the latter resulted in the creation of Carson County and a judge, Orson Hyde, who began to hear cases in a Genoa courtroom. All this came to naught, however, when, in 1857, Mormon leader Brigham Young recalled the faithful to the Salt Lake area to help defend against what he thought was an impending confrontation with the U.S. military. The response from Mormons along the eastern Sierra front was immediate. In late September, roughly 450 people loaded into 123 wagons and made their way back to Salt Lake. Among them was farmer Abraham Hunsaker, who expressed regret leaving what he called "the best farm I ever owned in my life."

Meanwhile, in the fall of 1851, six unsuccessful miners settled on land about ten miles north of Mormon Station, where their ranch also served as

a trading post for passing pioneers. Its location—in the vicinity of what is now the corner of Thompson and West Fifth Streets in Carson City—was similar to Mormon Station insofar as they both were at the western side of respective valleys with access to water from adjacent mountains. Truth be told, however, the Carson Valley Mormon settlement was the more favorable site. This rival trading post, as well as the valley itself, acquired its moniker after one of the men shot an eagle and nailed its feathers to the door of their crude hut. Later in the decade, Eagle Ranch, or Station, became the nucleus of Carson City.

Eagle Valley, wedged between more populous Washoe Valley to the north and Carson Valley to the south, slowly attracted more settlers. They homesteaded, for the most part, on the western side, where timber and water were readily available. These early pioneers included Dr. Benjamin L. King, for whom Kings Canyon is named, and Jacob Rose, whose name is attached to one of the highest peaks in the Tahoe Basin, Mount Rose. Eagle Station went through a series of owners, and the sudden departure of Mormon settlers from Eagle Valley meant that real estate was available—and often at a bargain price.

The land deal that became the foundation of Carson City can be traced directly to four individuals: Abraham Curry, Benjamin F. Green, John J. Musser and Francis M. Proctor. Of these, Abraham Curry clearly was the most enterprising, and historians often refer to Carson City as "Abe Curry's Town."

Abraham (or Abram) Van Santvoord Curry (1815–1873), a native of Ithaca, New York, was like so many of his contemporaries insofar as he got swept up in the California Gold Rush. In 1857, Curry and his teenage son Charles were living in the northern California mining camp of Downieville, where they met Green, Musser and Proctor. In July 1858, the four men decided to look for business opportunities on the eastern side of the Sierra Nevada, so they, along with Curry's son, took a stagecoach over the mountains and ended up in Eagle Valley. It was there they found their opportunity.

The most recent owner of the Eagle Station, as well as many acres of surrounding sagebrush, was one John Mankins. Curry and his partners made an offer on his land (amounting to 865 acres), as well as a half-section (320 acres) owned by his brother George, and the offer was accepted. The deed, dated August 12, 1858, represents the beginnings of Carson City, because Curry and his partners quickly hired a land surveyor from nearby Dayton (then called Chinatown) to lay out a town grid, or plat. The partners divided the lots among themselves and proceeded to sell to anyone willing to build a

Carson City Begins

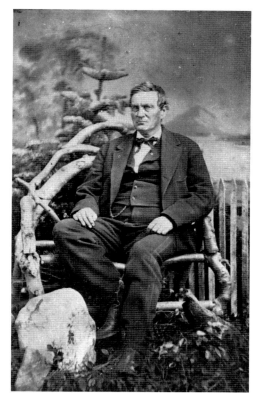

Right: Abraham (or Abram) V.S. Curry (1815–1873). *Courtesy of the Nevada State Library and Archives.*

Below: Carson Street in the 1860s. *Courtesy of the Library of Congress.*

home or business in the new town. Lot sales were based on the buyer's ability to pay, which encouraged the rapid growth of the community.

History records that Francis "Frank" Proctor actually selected the name for the town—Carson City—because of its proximity to the nearby Carson River. Curry soon found himself sole owner of most of Carson City, as his partners opted to concentrate on careers other than real estate speculation. Musser and Proctor returned to their previous occupations as attorneys, and Green, who had been a jeweler in Downieville, opened a jewelry and gunsmith business.

To say that Abraham Curry had a vision for Carson City reveals that he was incredibly prescient or lucky or both. While there was talk of separate territorial status for the region after the Mormons left and reports of encouraging finds in nearby Gold Canyon, Curry decided to reserve a four-acre parcel in the center of town for the future site of governmental buildings. He became the very definition of a town booster.

Abraham Curry did more than talk the talk; he became "Abe" the builder, beginning with his development of a nearby sandstone quarry. The same property had an area of warm springs, which Curry transformed into a public bathhouse and hotel. His Warm Springs Hotel, in fact, figured prominently in his political ambitions for Carson City becoming the meeting place of the first territorial legislature in 1861. Before looking more closely at Carson City's growth and Nevada's journey toward statehood, it is necessary to examine what was happening on the slopes of nearby Mount Davidson.

Prospectors had known about small quantities of gold in a canyon east of Carson City for some years prior to the 1859 discovery of the Comstock Lode. Named for pioneer prospector Henry T. "Pancake" Comstock, the lode of mostly silver with some gold came as some surprise to those who worked their claims up Gold Canyon. The first prospectors tried to apply placer-mining techniques they had used in the foothills of California. (The Spanish name *placer*, meaning a type of non-vein free gold, became the standard term of both the geologic deposit and the technology.)

To be most successful, placer mining requires running water, and some of the best "diggings" of the early California Gold Rush were in or near active stream channels. In the 1850s, the miners prospecting up Gold Canyon and Six-Mile Canyon (another canyon cutting into Mount Davidson) were hampered in their efforts by the general lack of running water. They were recovering enough gold to encourage them to continue, but they utterly failed to recognize silver deposits—which they called "blue stuff"—and

Carson City Begins

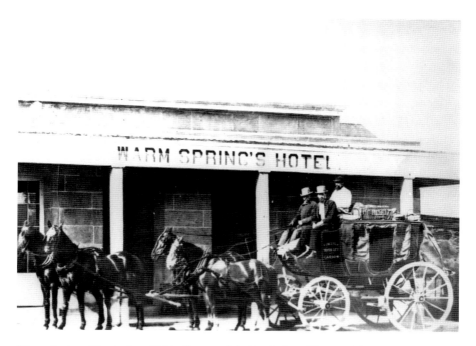

Warm Springs Hotel, circa 1860s. *Courtesy of the Nevada State Library and Archives.*

cursed because it impeded their search for gold. The blue stuff eventually was assayed, determined to be rich in silver content, and the Comstock Lode became the nation's first big silver strike.

Quartz veins and ledges containing gold and silver were eventually located in two places, Gold Hill and the Ophir claim in what became Virginia City, and the original locators realized the Comstock was not for placer but for hard-rock mining. Whereas placer miners remain on the surface and sort through loose sediments with pans, rockers and sluices, hard-rock miners go progressively deeper underground in their pursuit of precious metal within a matrix of solid rock.

Discovery and development of the Comstock Lode was Nevada's defining moment. It was similar to the California experience a decade earlier. The gold rush catapulted California past territorial status to full statehood in two and a half short years. It is worth remembering that when John Marshall found that famous gold nugget at Sutter's Mill on January 24, 1848, California and Nevada belonged to Mexico and the Mexican-American War had not yet been concluded. The "Rush to Washoe" in 1859 was not as dramatic as the California Gold Rush, but it was close.

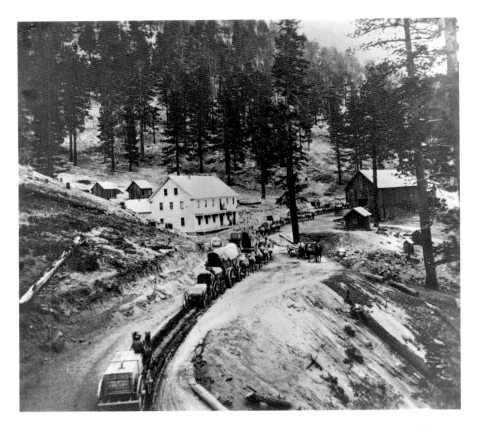

The Bonanza Road at Lake Tahoe near Glenbrook, circa 1860. *Courtesy of the Library of Congress.*

The mining rushes to California and Nevada transfixed national attention on the western horizon. To be sure, Americans had been moving gradually west since the conclusion of the American Revolution, but the mass migration to West Coast mines was somehow different. The fertile valleys from the Appalachians to the eastern edge of the Great Plains were settled in orderly fashion, and their umbilical-like connections were ultimately linked to East Coast centers of political and economic power. The mining centers of the West Coast collectively constituted a political exclave; the region was, for all intents and purposes, a Pacific Rim nation with its own primate city, San Francisco. Some, like Henry David Thoreau, worried about the get-rich-quick motivation of miners and other opportunists and the type of society taking root on auriferous gravels and in underground ore bodies. Mining, according to their view, was deemed a lowly livelihood vis-à-vis more

ennobling occupations such as farming. The same sentiment is expressed in the title of one of the best books on early Nevada—*Devils Will Reign: How Nevada Began* (2006) by Sally Zanjani.

The Comstock Lode came to encompass Virginia City, Gold Hill, Silver City and the town of Dayton in the Carson River Valley. Its nineteenth-century production of precious metals, mainly bracketed between the years 1860 and 1880, amounted to more than $300 million. During the "Big Bonanza" years of 1873 to 1879, when the mines yielded incredibly rich and vast ore bodies, the population reached nearly twenty-five thousand.

The growth of Carson City was directly tied to the Comstock mining boom, among other factors, and Carson City was, as they say, in the right place at the right time. The weakening hold Utah had on the western side of its territory, the phenomenal riches coming from the Comstock Lode and, perhaps most importantly, the brewing schism between North and South that resulted in the American Civil War, all coalesced to make Carson City a place of considerable importance. On March 2, 1861, President James Buchanan signed a bill that created three new western territories—Colorado, Dakota and Nevada.

Political appointments for the newly created Nevada Territory were made by incoming president Abraham Lincoln. The officials included New Yorker James W. Nye (1815–1876) as territorial governor and Missourian Orion Clemens (1825–1897) as territorial secretary. Orion Clemens was the elder brother of Samuel Clemens (a.k.a. Mark Twain), and the two brothers traveled by stagecoach to Carson City, a journey described with more than a little humor in the book *Roughing It* (1872).

Abraham Curry's dream of having Carson City designated the territorial capital had become a reality, and soon a building boom commenced. As mentioned earlier, the first meeting of the territorial legislature was at Curry's Warm Springs Hotel. Subsequent legislative meetings took place at Curry's newly built Great Basin Hotel, a solid sandstone structure on Carson Street now the site of the Nevada attorney general's office complex.

One of the first orders of business for the new territorial legislature was to subdivide the enormous territory—in essence, the western half of the Great Basin—into nine counties. For those not familiar with early Nevada geography, the state's largest modern cities—Las Vegas and Reno—were of little consequence back in 1861. Las Vegas was a small Mormon settlement, and Reno, called Lake's Crossing, was little more than a place to cross the Truckee River. The bulk of territorial population clustered in a rough triangle

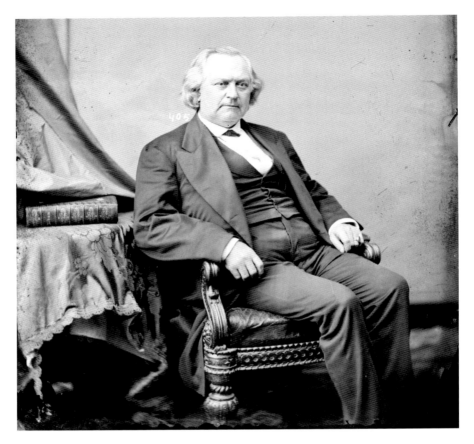

Nevada territorial governor and U.S. senator James W. Nye (1815–1876). *Courtesy of the Library of Congress.*

bounded by Carson Valley, Washoe Valley and the Comstock. Carson City was in the center, geographically and politically.

The decision to make Nevada the thirty-sixth state in the Union on October 31, 1864, is well reflected in the state slogan, "Battle Born." The Civil War was raging, President Lincoln was up for reelection and there was congressional interest in seeing that new states with constitutional provisions outlawing slavery be added to the Union. And Nevada was rich, very rich, which somehow overrode any considerations of having a minimum population size to become a state. As for Carson City, it had gone from being a dispersed settlement of ranches and homesteads to the capital of a state in a mere six years. Abraham Curry could not have been happier.

SANDSTONE, LUMBER AND BRICK

Given its location on the western edge of the Great Basin Desert, one would think Carson City would have had trouble finding suitable building material. That was not the case, however. Historic Carson City had its beginnings before the era of the building supply store, whose inventory was shipped in via rail from elsewhere, but perhaps somewhat surprisingly, materials were obtained from nearby sources. Those in the construction trade made use of locally available materials, with much of the town built of quarried sandstone blocks, dimensional lumber and brick.

The industrious Carson City founder Abraham Curry identified a sandstone outcrop on his property roughly two miles east of the town center. He developed this quarry, now synonymous with the Nevada State Prison property, insofar as it was easily obtainable, high quality and relatively close to his cherished town site. In addition, Curry used his sandstone building blocks in the construction of the two-story Warm Springs Hotel (built 1861). He recognized how nature had fortuitously provided a suitable building material immediately adjacent to a geothermal spring. Curry offered his hotel for the venue of the first session of Nevada's territorial legislature and later sold it, the sandstone quarry and some twenty acres to the new territorial government for $80,000. The solidly built Warm Springs Hotel became the first of many stone structures to comprise the prison, which remained in operation for the next 150 years.

A walk around Carson City today will reveal the extent to which prison sandstone formed a basic building block for the town. As one would

Alfred Chartz house, 412 North Nevada Street, built 1876. *Courtesy of the Library of Congress.*

expect, Abraham Curry's own house on the corner of North Nevada and West Telegraph Streets was built of stone. In *A Short History of Carson City* (2011), Richard Moreno described it as "a simple but elegant rectangular structure that boasted walls that were two feet thick and a large cupola with a skylight." A partial list of other Carson City residential, commercial, civic and religious buildings constructed with locally quarried sandstone includes the Nevada State Capitol, former State Printing Building, U.S. Mint, First United Methodist Church, Stewart-Nye House, Edwards House, Warren Engine Company No. 1, V&T Railroad shops (demolished) and Jack's Bar. Sandstone from the prison quarry was even used for gravestones, particularly those in Carson City's historic Lone Mountain Cemetery.

Lumber used to build the town was in generous supply thanks to Carson City resident Duane L. Bliss (1833–1907), whose former home is located at 710 West Robinson Street in the west side historic district. Bliss supervised the operations of the Carson and Tahoe Lumber and Fluming Company with the community of Glenbrook on Lake Tahoe's east shore, a center

Carson City Begins

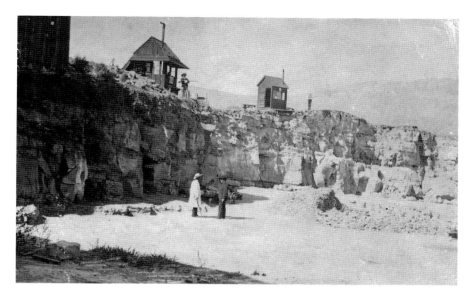

Sandstone quarry at the Nevada State Prison, Carson City. *Courtesy of the Special Collections Department, University of Nevada–Reno Libraries.*

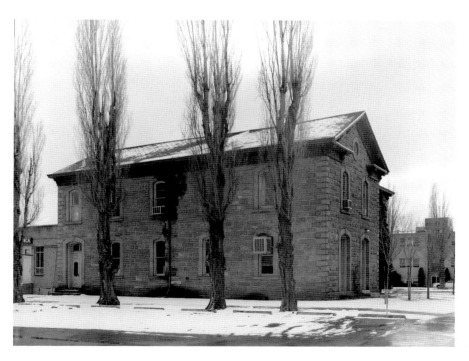

Nevada State Printing Office. *Courtesy of the Library of Congress.*

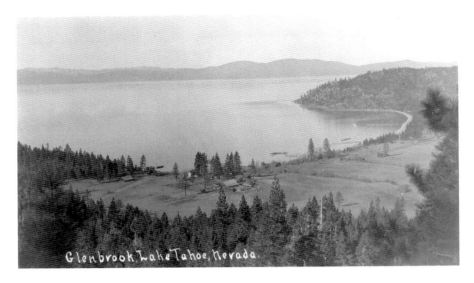

Glenbrook, Lake Tahoe. *Courtesy of the Library of Congress.*

of industrial lumbering. The impetus for cutting most of the old-growth forests in the Tahoe Basin was not so much to supply Carson City with building material—that was almost incidental. The major market for Bliss's lumber output lay on the slopes of Mount Davidson beyond Carson City. The communities of the Comstock Lode, particularly Virginia City, had a seemingly limitless appetite for wood. In actuality, demand for mining timbers below ground was greater than demand for lumber above ground, so much so that an editor of the *Territorial Enterprise*, William Wright (a.k.a. Dan De Quille), once quipped, "The Comstock lode may truthfully be said to be the tomb of the forests of the Sierras." Nevertheless, Carson City benefitted from lumber making its way from Lake Tahoe's forests to the Comstock.

From the Carson and Tahoe Lumber and Fluming Company sawmills on Lake Tahoe, the dimensional lumber, mining timbers and cordwood was loaded onto narrow-gauge railroad cars and hauled up to Spooner Summit. From there, a large V-shaped flume carried these wood products down Clear Creek to a massive lumberyard south of Carson City. Water as a lubricant and gravity propelled this lumber at sixty miles per hour down to the valley some twelve miles and 2,500 feet below. Renowned photographer of the American West, Carleton E. Watkins (1829–1916), captured several images of this process during its 1870s heyday, the most impressive of which is a

Carson City Begins

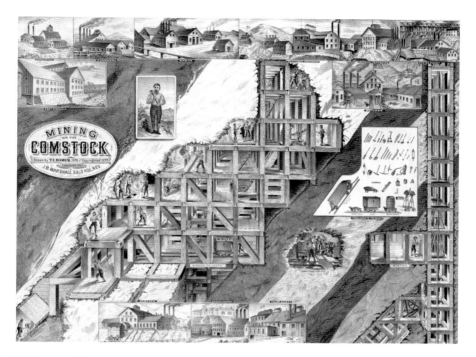

Underground square-set timbering of Comstock Lode mines illustrated by T.L. Dawes, 1876. *Courtesy of the Library of Congress.*

shot showing acres of lumber surrounding a V&T locomotive. According to State Historical Marker No. 193, the lumberyard was huge, measuring one mile long and half a mile wide. The Carson and Tahoe Lumber and Fluming Company lumberyard's location, a little over half a mile south of the junction of South Stewart and South Carson Streets, is now covered by a commercial corridor.

Bricks were a fundamental building block of Carson City, largely because every house needed a brick chimney. Several brick kilns and brickyards sprang up to fill this need. Making bricks was a time-honored tradition, and several early settlers of Carson and Eagle Valleys brought this valuable skill with them. Thompson and West's *History of Nevada* (1881) contains a biographical sketch of one such artisan, John Adams: "In early life the subject of this sketch learned the brick makers' trade [and in 1853, he moved to Carson Valley].…Going back to his former business he made the brick used in the construction of the United States Branch Mint, at Carson City, also for the Court House at Genoa." Additionally, the General Land Office plat map of Carson City (1864) identified a "Brick Kiln, Brick

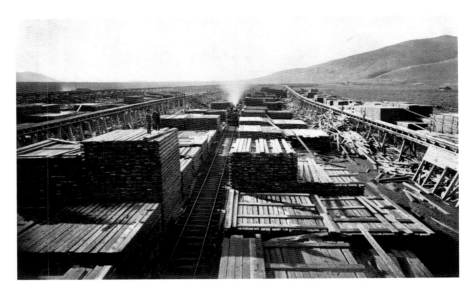

Carson and Tahoe Lumber and Fluming Company lumber yard near Carson City. Photograph by Carleton E. Watkins, 1876. *Courtesy of the Special Collections Department, University of Nevada–Reno Libraries.*

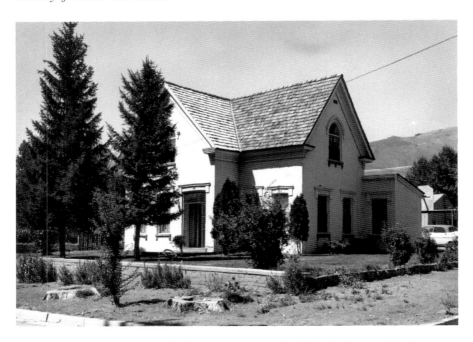

Ormsby-Rosser house, 304 South Minnesota Street, built 1862–63. *Courtesy of the Nevada State Library and Archives.*

Yard" approximately three-quarters of a mile south of the center of town. This would place it in the general vicinity of what is now the Humboldt-Toiyabe National Forest office on South Carson Street.

Most early Carson City residential construction consisted of wood-frame buildings, but there were a few notable brick houses, including the Ormsby-Rosser House on South Minnesota Street in the west side historic district. According to its National Register of Historic Places (NRHP) nomination form prepared in 1979, "The Ormsby-Rosser house, built during the winter of 1862–1863 and lived in by important figures in Nevada's early history, is a substantial building representing one of the few remaining brick residences from that era." The NRHP nomination form goes on to explain, "Mrs. Ormsby had this house constructed of bricks made in T.T. Israel's brickyard, not far away from the house site. Israel was also the building contractor. Mrs. Ormsby's brother, John K. Trumbo, was a lumber merchant and supplied the clear, knot-free pine used in the construction."

PART II
PLACES

EAST MEETS WEST IN CHINATOWN

Like many cities and towns in the West, Carson City had a sizeable Chinese population. These Overseas Chinese, as they are sometimes called, came first as participants in the California Gold Rush. From 1850 to 1855, more than twenty-seven thousand Chinese came to "Gold Mountain," their term for the California Mother Lode country. Thousands of Chinese laborers later built the western half of the transcontinental railroad. In urban environments, Carson City included, they clustered in neighborhoods universally labeled Chinatown. Arguably, the Chinatown best known to Americans is in San Francisco, which is still a vibrant and populous section of the City by the Bay.

Nothing remains of Carson City's Chinatown save for a historical marker at the edge of a municipal parking lot on the corner of South Stewart Street and East Third Street. At one time, however, this area just a couple blocks southeast of the state capitol was home to perhaps one thousand Chinese residents. According to the 1880 census, roughly 90 percent of those enumerated were male—a demographic pattern consistent with overall immigration figures for the nineteenth century. Historian Sue Fawn Chung noted that although the census taker identified families with children, they were clearly in the minority; most of Carson City's Chinatown residents were men of working age who held jobs both within and beyond their immediate community.

Residents of Carson City's Chinatown lived in this cultural enclave because of their shared ethnic identity and in order to insulate themselves

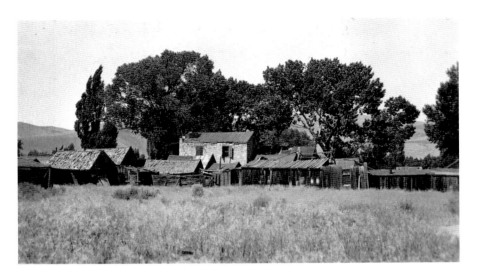

Part of Carson City's Chinatown, 1935. *Courtesy of the Special Collections Department, University of Nevada–Reno Libraries.*

as best they could from an atmosphere of racism imposed by the dominant society. Carson City's Chinese population had good reason to remain as low profile and circumspect as possible. They were aware of the growing national anti-Chinese sentiment, which culminated with the Chinese Exclusion Act of 1882. Most of this racial prejudice and discrimination resulted from real or perceived labor competition. Incredible as it may seem today, there were even anti-Chinese clubs in some Nevada communities, Carson City included. Noted Nevada historian Wilbur S. Shepperson pointed out that as early as 1860, a committee of safety was organized by local whites, whereupon they raided Carson City's embryonic Chinatown and attempted to evict its population. Even newspapers such as the *Carson Daily Index* and *Carson Appeal* covered "Anti-Chinese Mass Meetings" and "Anti-Coolie [Chinese] Meetings."

Despite the years of prejudicial rhetoric and blatant discrimination, Carson City's Chinatown survived—and some would say even thrived. The five blocks more or less centered on East Third Street between Fall and Anderson Streets constituted the largest Chinatown in Nevada. According to Sue Fawn Chung, "Carson City's Chinatown was a communication and transportation center for neighboring Chinatowns, such as the one in Virginia City.…[L]arge merchandising firms handled the imported silk garments, lumber, foodstuffs, medical care, and herbal medicines between

the 1850s and the 1890s." Carson City's Chinatown, in addition to having a substantial resident population, supported the needs of a widespread population of Chinese railroad workers, woodcutters and ditch diggers, insofar as most were employed as general laborers. Many workers came to live in Carson City with the completion of projects such as the Central Pacific and Virginia and Truckee Railroad lines.

Historic maps and archival photographs show that Carson City's Chinatown was a collection of mostly wood-frame one- and two-story houses, with the inclusion of some stone, brick and adobe buildings as well. Thanks to a series of maps produced by the Sanborn Fire Insurance Company, individual buildings are described in terms of dimensions, building material and function. It is clear that Chinatown consisted of a mixture of residential and commercial buildings, and thanks to census records, newspaper accounts and other documents, many of those residents and merchants are known by name, if not by reputation. Dr. Ah Kee, for example, established a thriving medical practice and is listed in the 1866 Ormsby County Assessment Rolls as owning several houses, a large inventory of drugs and medicines and even five hogs and thirteen chickens. Another Chinese resident of note was Kow On, a successful merchant who, according to his obituary in the *Carson Appeal*, arrived during construction of the Virginia and Truckee Railroad and stayed on in Carson City until his death in 1930. Other prominent citizens include Yee Bong, Gee Hing, Kookhi Leo, Wang Li, Dr. Gee Tong and Nam Wah.

Carson City's Chinatown also contained competing *tongs*, which functioned in the United States as Chinese secret societies or brotherhoods with ties to labor, not unlike modern labor unions. They are said to have engaged in criminal activity, although it appears they mostly functioned as an intermediary between their membership and the outside world of European Americans. Newspapers of the time make it appear as if "tong wars" were common in Carson City's Chinatown, with headlines such as "Bloody Business in Chinatown," "More Muss in Chinatown," "A Great Battle Expected," "Pitched Battle—Tong War" and "Murder in Chinatown," among others. This internal violence has been attributed, by and large, to the huge sums of money to be made or lost in contracting out Chinese labor. Be that as it may, Carson City was not isolated in its organizational connections; the Chinese Six Companies Association and the Chinese Freemasons, both with branches in Carson City, had their national headquarters in San Francisco.

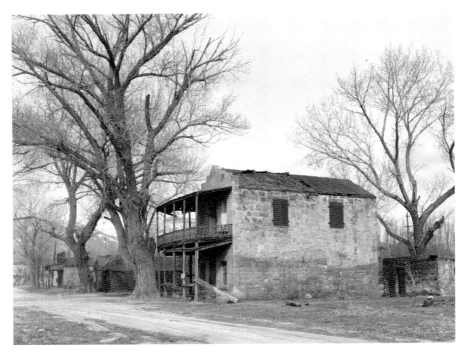

Two-story building in Carson City's Chinatown. Photograph by Gus Bundy, 1944. *Courtesy of the Special Collections Department, University of Nevada–Reno Libraries.*

By the 1930s, Carson City's Chinatown had become a shadow of its former self. A 1935 conflagration destroyed many commercial buildings in the contiguous five-block neighborhood, and by 1937, there were only thirteen Chinese residents left. Although what little remained of Chinatown has been demolished to make way for a state building and additional parking, Chinatown is not lost to those who have an interest in the past of Nevada's capital city. One block north on South Stewart Street, for example, is the Nevada State Library and Archives, where one can find additional information on Chinatown, such as Jack Curran's fascinating chapter on Chinatown in his memoir *Back to the Twenties* (1994). In it, he wrote, "Chinatown is all gone now, with not even one building remaining, and it's hard to tell it was once there.…The Chinese were a potent force in the settlement and building up of the American West, and a very important part of Nevada's early history. I was lucky to know some of them."

CARSON'S RED-LIGHT DISTRICT

There was a time when Nevada's capital city had a red-light district. What is more, these houses of prostitution were situated only two blocks from the state capitol complex, not discreetly tucked away in a quieter and less conspicuous part of town. According to former Nevada state archivist Guy Rocha, these popular brothels were on the street behind Jack's Bar, a historic watering hole on the northwest corner of South Carson and West Fifth Streets, and "were closed by federal order in 1942." Prostitution, however, remains legal in Nevada's rural counties, as is evident when one drives east from Carson City into Lyon County, where billboards advertising several brothels are prominent on the landscape along Highway 50.

Nevada's somewhat raucous mining communities like Virginia City were famous for their red-light districts, and some individual prostitutes like Julia Bulette (1832–1867), whom historian Susan James called the "Queen of Tarts," are venerated to this day. Even the wholesome television show *Bonanza* portrayed Nevada's seemingly dichotomous morality when it aired an episode on October 17, 1959, in which "Little Joe" Cartwright fell in love with Julia Bulette.

There may not be any historical marker to identify Carson City's former red-light district, but it was a well-known section of town for many years. Historians have no doubt as to its location; it was described in the newspaper, placed on a map and discussed in published anecdotes about Carson City from its early days to World War II. Especially interesting is a Carson City ordinance published in the *Carson Daily Appeal* on June 9,

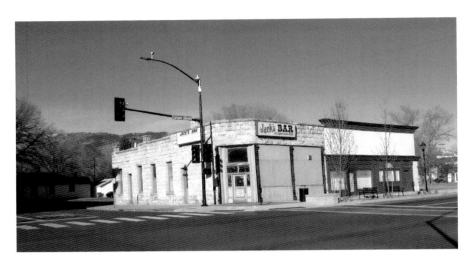

Jack's Bar, 418 South Carson Street, built 1859. *Photograph by the author.*

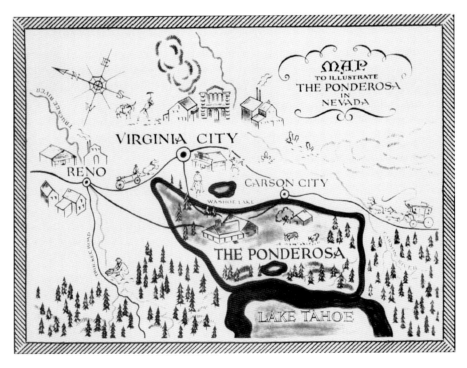

Map of the "Ponderosa Ranch" from the television show *Bonanza*, which aired from 1959 (the Comstock Lode centennial) to 1973. *Courtesy of the Nevada State Library and Archives.*

1875, limiting the location of brothels to a three-block section of Ormsby (now Curry) Street. It is known as Ordinance No. 24 and was signed by the president of the board of trustees and the city clerk.

> *An Ordinance in relation to Houses of Illfame in Carson City.*
> *The Board of Trustees of Carson City do ordain:*
> SECTION 1. *After the 1st day of October, A.D. 1875, no house of illfame shall be opened, kept, or used as such, in Carson City, except on Ormsby street* [now Curry Street], *between Second and Fifth streets, and back east and west to the alleys in the blocks in said limits; and any house in said city, out of said above named limits, now open, kept or used of* [sic] *a house of illfame, or which may prior to the 1st day of October, A.D. 1875, be open, kept or used as a house of illfame, shall on or before the 1st day of October, A.D. 1875, be closed, and shall not thereafter be opened, kept or used as a house of illfame.*
> SEC. 2. *The term, "House of Illfame," as used in this Ordinance, shall for all purposes of this Ordinance be construed and held as synonimous* [sic] *with, and to mean the same as, "House of Prostitution," or "Bawdy House."*
> SEC. 3. *A violation of the provisions of the first section of this Ordinance shall be deemed a nuisance, and any person duly convicted thereof, shall be punished by a fine of not exceeding five hundred dollars, in United States gold coin, or by imprisonment not to exceed six months in the city jail, or by both such fine and imprisonment, in the discretion of the court before which conviction is had.*
> *Adopted June 7, 1875.*

This city ordinance is quoted in its entirety for two reasons: it clearly identifies the red-light district's boundaries—on Curry between Second and Fifth—and it shows, through contemporary language, a certain amount of ambivalence toward prostitution. Brothels in Carson City were tolerated but subject to what amounts to a zoning law. It was a tacit recognition that this activity took place, and confining it to a specific part of town, in a sense, made the rest of Carson City family-friendly by default.

Cartographic documentation of Carson's red-light district comes from several examples, one of which is an 1885 map of the city's core area produced by the Sanborn Fire Insurance Company. Sanborn maps, as they are commonly called, were produced for hundreds of U.S. cities and towns from the Gilded Age until well into the twentieth century. Although they

Former brothel, 202 West Fifth Street. *Photograph by the author.*

initially served the insurance industry, they are now invaluable research tools. The 1885 Sanborn map, which is actually four contiguous map sheets, covers most of the downtown part of the city, and sheet three shows the red-light district. Significantly, one house on the southwest corner of Ormsby (now Curry) and Fourth Streets is labeled "Palace." This can only mean one thing—a high-end brothel. One could even joke that in addition to the several elegant homes in the west side historic district referred to as mansions, there was also a palace.

Historian Willa Oldham related a story in her book *Carson City: Nevada's Capital City* (1991) about the nearby Rinckel Mansion and a case of mistaken identity. "Marcella Rinckel, at her elegant mansion two blocks north of the district, only enjoyed her new Paris-purchased, georgette-covered lamp a few days—its red glow was being mistaken for a new district 'house.'" She goes on to tell how Mrs. Rinckel's young daughter once went in search of her cat that had wandered off, only to return with the cat and a glowing report of "all those nice ladies" a couple blocks down the street.

Some of Carson City's madams and prostitutes are known by name. Jennie Moore, an African American, ran a house on the northwest corner

PLACES

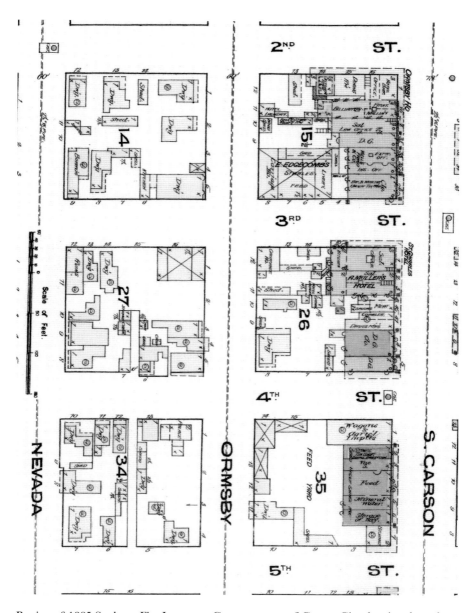

Portion of 1885 Sanborn Fire Insurance Company map of Carson City showing the red-light district. Note the building labeled "Palace" on the southwest corner of West Fourth and Ormsby (now Curry) Streets. *Courtesy of the Library of Congress.*

of what is now South Curry and West Third Streets. Mary Ann Phillips is said to have had a private residence in Virginia City where she raised her children; at the same time, she was the owner and operator of the "Palace" mentioned above, which she bought in 1874. She is buried in Carson City's Lone Mountain Cemetery. Emma Goldsmith was another madam in Carson City, known primarily for her friendship with Carson City's most famous prostitute, Rosa May.

In his first-person narrative, *Rosa May: The Search for a Mining Camp Legend* (1979), author George Williams III shared his research into Rosa May's life and times made all the more personal and poignant through an incomparable collection of letters. In addition to working in Carson City in the halcyon days of the 1870s, Rosa May spent time in Virginia City and, later, in the mining boomtown of Bodie, where she died sometime during the winter of 1911–12. Her biography, which traces a career in prostitution from her early twenties to her late fifties, illustrates the fundamental tragedy of her life.

Nevada's red-light districts, including the one in the capital city, may add to the Wild West reputation of the state, but a closer look at the lives of the women involved reveals a dark side. The celebrated Julia Bulette was murdered. Emma Goldsmith is said to have become an opium addict and was later diagnosed as insane. And Rosa May, who in her twenties may have been the toast of the town, died alone and impoverished and was buried in an outcast cemetery.

PARKS AND RECREATION

On the east side of town, south of William Street and beyond Chinatown and other residential neighborhoods, there once was a racetrack. It is shown on several old maps, including an 1875 bird's-eye view of Carson City drawn by cartographer Augustus Koch. The old racetrack is but one example that residents of the state capital valued their leisure time and enjoyed being outdoors. A substantial park and popular picnic spot on the west side of town, once a part of Aaron Treadway's ranch, is another example. The sites of both the racetrack and the park are still evident today if one knows where to look.

Horse racing has a long tradition of popularity in America, and Carson City had its own racetrack in the latter half of the nineteenth century. Before casino gambling was legalized in Nevada in 1931, betting on the horses was considered a socially acceptable alternative. A poster advertising the 1892 Ormsby County Fair, for example, boasted "liberal purses and premiums." Needless to say, there was considerable interest in horses for many reasons, not the least of which was that horsepower was the fastest form of conveyance available to most people.

Thoroughbred racing's Triple Crown—the Kentucky Derby, the Preakness and the Belmont Stakes—remains a tradition celebrating the speed and excitement of the race. Harness racing, where a sulky replaces the saddle, is a spin-off form, and in fact, the 1875 bird's-eye map of Carson City shows harness racing taking place. In reality, both forms of horse racing were doubtless popular in Carson City.

Lost Carson City

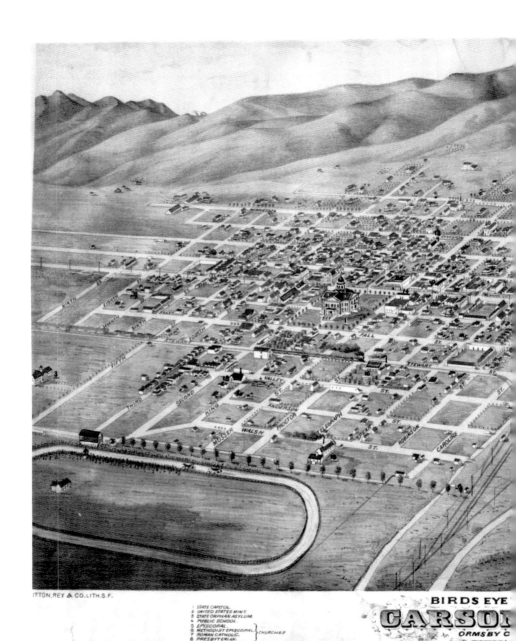

Places

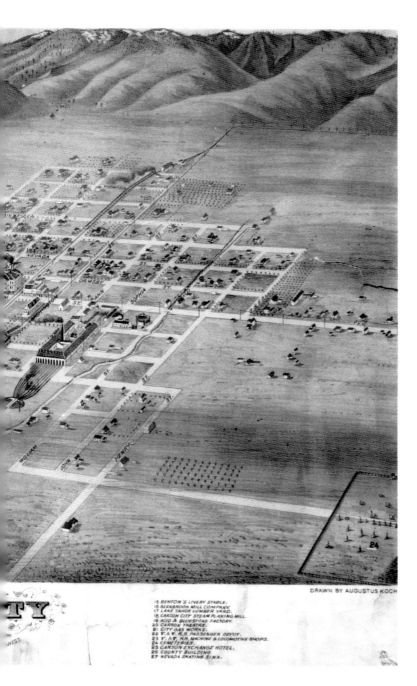

Bird's-eye view of Carson City drawn by Augustus Koch, 1875. *Courtesy of the Nevada State Library and Archives.*

Lost Carson City

In the latter half of the nineteenth century, horses constituted an essential form of transportation. The coming of the transcontinental railroad to Reno in 1868 and the completion of the V&T Railroad connection in 1872 alleviated much of the freighting component involving horse-drawn wagons, but horses remained a necessity for most people until being replaced by the automobile in the 1920s. Many local ranches bred horses for a variety of purposes, including race horses. The Winters Ranch in adjoining Washoe Valley, for example, bred fine race horses, and the racetrack behind the Winters's beautiful Carpenter Gothic house, which still stands beside old Highway 395, was a popular venue for horse races.

Ironically, the Carson City racetrack gained fame and notoriety not because of any of its contests involving horses but because of a contest involving two people. On March 17, 1897, the racetrack was the site of the world heavyweight championship prizefight between James J. "Gentleman Jim" Corbett, the reigning champion, and Bob (Robert) Fitzsimmons. The challenger held the title of New Zealand champion. Nevada was selected as the venue for the fight because prizefighting was illegal almost everywhere else. The stadium seating at the old racetrack was expanded, and a wooden arena and ring were constructed especially for the event. The world came to Carson City. The roughly six thousand spectators included former champion John L. Sullivan, famous lawman Wyatt Earp, gunfighter-turned-sportswriter Bat Masterson and Nevada governor Reinhold Sadler. The fight promoters even built a special section for the few women in attendance, one of whom, Nellie Mighels Davis, covered the fight for a Chicago newspaper.

The fight lasted fourteen rounds, with the challenger Fitzsimmons coming back from a near knock out in the sixth to win. Interestingly, the 1897 Corbett-Fitzsimmons fight was the first bout ever filmed, and despite a national aversion to what many considered barbaric behavior, it became a sensation in movie theaters across the country. It was also the first film made in Nevada.

On the other side of town, a small remnant of a park still exists at the west end of William Street. One clue as to its location is a stand of old cottonwood trees planted in the 1860s. According to a 2009 article in the *Nevada Appeal*, which covered the rededication of this preserved landscape now owned by the city, Treadway Park not only was a popular recreation spot for locals but also has the honor of being "the first park, public or private, in Nevada."

Aaron D. Treadway (1816–1903) acquired considerable landholdings on the west side of Carson City in 1861 and became a successful farmer.

Places

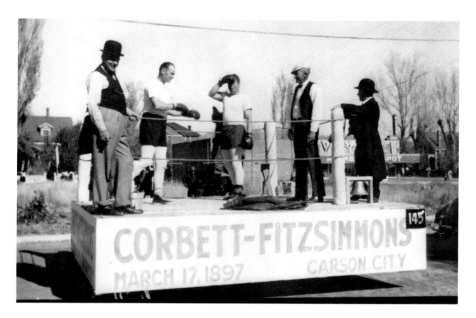

Corbett-Fitzsimmons fight, 1897. *Courtesy of the Nevada State Library and Archives.*

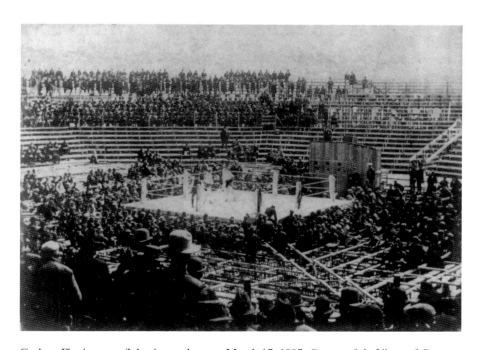

Corbett-Fitzsimmons fight ring and arena, March 17, 1897. *Courtesy of the Library of Congress.*

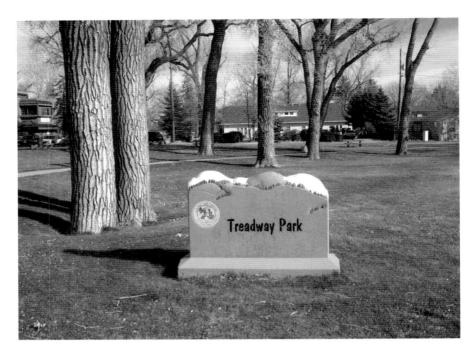

Treadway Park. *Photograph by the author.*

Treadway initially came west during the California Gold Rush but ultimately ended up as one of the early settlers of Eagle Valley. He transformed his 110 acres of land immediately west of town into a flourishing farm, planting fruit trees, raising livestock and even stocking a pond with catfish. He is credited with planting cottonwoods; many of these now-giant trees are still all over the western edge of Carson City's historic district.

Richard Moreno, in *A Short History of Carson City* (2011), wrote, "In 1866, 'Farmer' Treadway opened [part of his] ranch to the public, offering, for a nominal fee, use of his shaded lands for picnics and games. When the Virginia & Truckee Railroad was built through Carson City, it skirted the southern border of his property; this proximity allowed groups to run train excursions to his ranch, which became known as Treadway Park." One such group to utilize this lovely park was the Miners Union up in Virginia City. For many years, this group held its annual picnic at Treadway's Ranch in Carson City, in large part because nothing like it existed on the slopes of Mount Davidson.

PLACES

Treadway Park has had a couple of noteworthy associations over the years. For a time in 1898, it was a camp for Nevada volunteers who were training to fight in the Spanish-American War. This short-lived parade ground and tent encampment, dubbed Camp Clark, left no permanent trace, as the war ended before the Nevada troops could be shipped off to either Cuba or the Philippines. Secondly, part of Treadway Park became the site of the original Carson-Tahoe Hospital in 1949. The hospital moved to its new location in the north end of town in 2005, with the old hospital complex being sold to a private company.

PART III
BUILDINGS

WORTH A MINT

Carson City once had a U.S. Mint, which puts Nevada's capital city in the company of a limited number of places where our national coinage has been produced. Actually, there are only nine past and present U.S. Mints, four of which—Philadelphia, San Francisco, Denver and West Point, New York—are still in operation. The Carson City Mint produced gold and silver coins from 1870 to 1893, and these have been, and remain, highly sought after by coin collectors (a.k.a. numismatists) worldwide. Especially popular are the Morgan silver dollars, which naturally have the distinctive "CC" mint mark on the reverse (back, as opposed to the obverse, front).

The mint building, now the Nevada State Museum, is one of the major landmarks of Carson City. It is located at 600 North Carson Street, four blocks north of the state capitol complex. Although today only several front rooms of the interior are devoted to telling the story of the mint, the exhibits are more than sufficient to give a sense of the building's place in local, state and national history. Especially noteworthy are an original coin press and the vault containing the Norman H. Biltz collection of CC coins. The former still produces commemorative coins from time to time, and it is the lucky visitor who gets to watch this 1870 coin press in operation. The latter is an incomparable collection that was donated to the State of Nevada in 1999 by Wells Fargo Bank, and one can immediately appreciate why it resides in a vault.

The U.S. Congress has authority over any mint, with the Treasury Department having considerable say in the matter as well. To understand

the genesis and ultimate demise of Carson City's mint, it is necessary to see it within a national context. The U.S. Mint in Carson City, like the State of Nevada, was battle born. That is to say, the Civil War (1861–65) was responsible for congressional approval of a mint in what was then the capital of Nevada Territory. In 1861, there were three U.S. Mints located in the Confederate states of North Carolina, Georgia and Louisiana—the one in New Orleans being the most important. They were obviously no longer available to the Union, which prompted the passing of federal legislation authorizing the Carson City Mint in March 1863.

Carson City founding father Abraham Curry is given credit for convincing Congress that his city was the right location for a new mint. Of course, the city's proximity to the Comstock really decided the matter; since 1859, it had received national attention for its rich gold and silver deposits, thanks to J. Ross Browne's articles in *Harper's Weekly*, among other widely read publications of the day. Another consideration was that some bullion going in and out of the U.S. Mint in San Francisco made its way overseas instead of remaining in the country, the result of Pacific-Rim business dealings.

After several years of delay, partially due to Washington's preoccupation with winning a war, the cornerstone for the Carson City Mint was finally

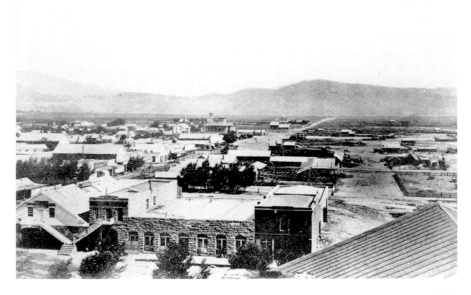

View of Carson City from the state capitol dome looking north, circa early 1870s. Note U.S. Mint in the center of the photograph. *Courtesy of the Library of Congress.*

BUILDINGS

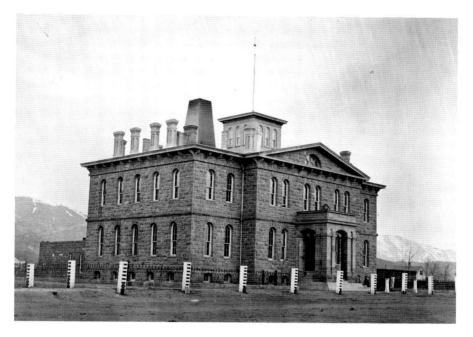

U.S. Carson City Mint, 600 North Carson Street, completed in 1869. *Courtesy of the Library of Congress.*

laid on September 24, 1866, and construction begun. In what may appear today as a conflict of interest, this was clearly Abraham Curry's project; he was one of three commissioners to oversee the mint's construction, he was the contractor who supplied the sandstone from his quarry at the Nevada State Prison and he became the mint's first superintendent. According to Howard Hickson's authoritative monograph on the mint, *Mint Mark "CC": The Story of the United States Mint at Carson City, Nevada* (1972), "Abe had been so deeply entangled in the procuring, construction, and first operations of the mint on North Carson Street, that some people said that the mark 'CC' on the coins minted there did not designate Carson City, but 'Curry's Compliments.'"

Not surprisingly, the final cost of the project to U.S. taxpayers was $426,787.66, a small fortune in 1869 dollars. (The original budget was $150,000.) The Carson City Mint opened for business on January 6, 1870, and the first coins bearing the CC mint mark were struck on February 11 of that year. Interestingly, the Carson City Mint mark is the only one to contain two letters; coins from all the other U.S. Mints bear only a single

letter (e.g., "P" for Philadelphia, "S" for San Francisco and "D" for Denver). The reason for the double letters was that the letter "C" had already been used; from 1838 to 1861, gold coins bearing the mint mark "C" were struck in a U.S. Mint in Charlotte, North Carolina.

The Carson City Mint provided a significant source of employment for the community. In its heyday, more than seventy-five people worked at the mint: administrators and clerks, melters and refiners, coiners, assayers and, of course, a large number of security guards. With all that gold and silver being handled by so many, numerous procedures were scrupulously followed at every stage in the minting process—from ingots to finished coin. Mint employees had to account for any discrepancies, such as a difference in precious metal weight during production processes. As an added precaution against theft, mint employees actually handling gold and silver during the course of their shifts were required to wear clothing without pockets. These outfits were kept in a changing room and never left the premises. (The mines of the Comstock Lode had a similar changing-room requirement.)

Despite all precautions, there were two federal investigations of the Carson City Mint. In 1881, the U.S. Secret Service followed up on a report that gold ingots were being "sweated," a procedure whereby some gold is siphoned off and a less-precious metal substituted. The mint again came under scrutiny in 1895, two years after it had ceased producing coins and functioned primarily as an assay office and processer of bullion. The earlier case was never proven, but the later one did document the loss of $75,549.75 in gold (which was never recovered). Four employees were implicated; one died before the trial, one was found guilty of a lesser charge and two were sentenced to eight years apiece at the Nevada State Prison, a building ironically constructed of the same sandstone blocks as their former workplace.

During its years of operation, the U.S. Mint at Carson City produced nearly $50 million in gold and silver coinage. The last coin was minted just prior to June 1, 1893, when an order from the acting U.S. Mint director specified that it cease operation and "mothball" its machinery and equipment. The building remained a federal office, mostly doing mundane assay work until 1933. In 1939, the State of Nevada bought the old mint, and two years later, it was transformed into the Nevada State Museum.

So the Carson City Mint is both a historic landmark in Nevada's capital city and a place considered near and dear to the hearts of coin collectors worldwide. In *The Mint on Carson Street* (2003), Reno numismatist Rusty Goe reflected on the collecting of a little piece of history in the form of a silver or gold coin: "From all of this emerged the coinage that has become the

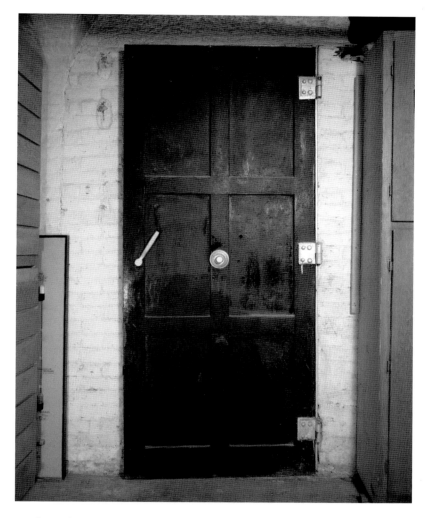

Door to the vault in the basement of the U.S. Mint in Carson City. Photograph by Aaron A. Gallup, 1972. *Courtesy of the Library of Congress.*

most popular, as a whole, of all the coins ever minted in the United States." There are still plenty of CC coins available for sale in stores and online, but there is one CC coin in particular that everyone keeps looking for: an 1873 CC *Without Arrows* dime. There is only a single known example of this dime, and in 1996, it sold for $550,000 at a coin auction in New York City. There should be more out there somewhere. Perhaps there is one lost in the depths of your junk drawer waiting to be discovered.

ARTS AND ENTERTAINMENT

I magine a time before radio, television and the internet. Actually, it was not that long ago. What did folks do for entertainment? Well, they read more for one thing; they talked to one another more face-to-face, worked at crafts and hobbies, played music and sang in the parlor and generally participated in a domestic life typical of the Victorian era. Communities like Carson City supported public venues such as an opera house where people would gather for a lecture or a play or a concert. Upon closer inspection, Carsonites enjoyed a vibrant and varied social life where arts and entertainment were concerned.

The opera house as a social institution once enjoyed a prominent place in towns and cities across the country. Anyone who has visited the National Historic Landmark of Virginia City and toured the historic Piper's Opera House on B Street has a sense of how central a place like this was in the life of a community. (Piper's actually had three iterations due to the destruction of the first two.) Perhaps a little contrary to its name, an opera house, at least the American version of one, was not used exclusively for opera. It provided a public gathering place for all sorts of performances and events ranging from the ever-popular Shakespeare to circus acts, minstrel shows, lectures and, of course, the occasional opera. Some big names appeared at Piper's over the years: members of the theatrical Booth family (but not the presidential assassin John Wilkes Booth); actresses Lillie Langtry and Maude Adams; influential minister and reformer Henry Ward Beecher; the "March King" John Philip Sousa; and entertainer Al Jolson, to name but a few.

Buildings

Carson City benefited by its proximity to wealthy and populous Virginia City in many respects, including in the arena of entertainment. Performers appearing at Piper's could often be persuaded to make an appearance in Carson City, considering it was on the way. One celebrity to entertain residents of the capital city was the former resident and rising star Mark Twain, who gave two public lectures in Carson City—April 29 and 30, 1868. By this time, he had made a name for himself, and the people of Carson City could proudly proclaim, "We knew him when."

Twain's appearance in Carson City actually predated by a decade the construction of the first of two opera houses. The first Carson Opera House was built on the southeast corner of Carson and Spear Streets in 1878. It remained in operation until 1888, when it was either demolished or dismantled to make way for the new federal post office and courthouse (now the Paul Laxalt State Building). The second opera house was built on the northwest corner of East Spear and North Plaza Streets (now underneath the footprint of the Carson Nugget Casino) the same year its predecessor was torn down. The two-story wooden building was considered a more than ample structure for its day. At a time when Carson City's population was a mere two thousand, the second opera house could seat eight hundred people. Following the national obsession with film, the popular gas-lit dance hall and

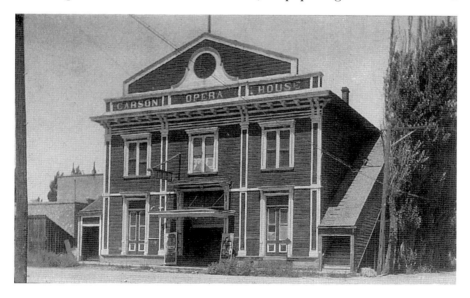

Second Carson City Opera House, formerly located on the northwest corner of East Spear and North Plaza Streets (now underneath the footprint of the Carson Nugget Casino), built in 1878 and destroyed by fire on April 4, 1931. *Courtesy of Southerland Studios.*

theater morphed into a movie theater in the 1920s, and unfortunately, the structure succumbed to fire on April 4, 1931.

Although the manager of such a place as an opera house would usually exist in the shadow of those in the limelight, this was not so for Carson's John P. Meder (1848–1908). J.P. Meder, as he was universally known, had musical talent that went unappreciated at his day job of freight agent for the V&T Railroad. Eventually, he succeeded in living out his true passion; he became manager of the Carson Opera House, where he directed numerous theater productions and performed many of his own compositions with a dance band. His best-known composition, "The Hank Monk Schottische," honors the celebrated stagecoach driver who famously took Horace Greeley on the ride of his life at breakneck speed from Carson City to Placerville. J.P. Meder also served as organist at St. Peter's Episcopal Church for many years. Meder's house, built around 1875, still exists at 308 North Nevada Street in the west side historic district. He and the subject of his most famous composition, Hank Monk (1826–1883), are buried in Carson City's Lone Mountain Cemetery.

Once the second Carson Opera House transitioned to a movie theater in the 1920s, it became an iconic temple of the silver screen. Jack Curran (1911–1999), in his memoir *Back to the Twenties* (1994), described what it was like going to the movies here before the old building's 1931 conflagration. Perhaps some of what he says strikes a familiar chord with moviegoers of a later generation.

> *Chautauquas, minstrel shows, traveling repertory companies and vaudeville troupes would appear on rare occasions, all well ballyhooed by even gaudier posters than usual....Big lithographed posters, extremely bright colored and always printed slightly off register, were displayed on either side of the main entrance, along with "stills" taken from the movies. These were very much in demand when discarded....Inside, the long sloping floor was furnished with squeaky, uncomfortable seats, the twin aisles covered with a sort of jute matting. The empty and unused opera boxes, once filled by notables of the town, sat there as symbols of a much more elegant time. A few dimly lighted seats, next to the walls, were favorite courting places for the younger adults.... The creaky old balcony was definitely the favorite rendezvous of our junior set.*

Are there still old movie theaters like that around, or have they all become multiplexes with surround sound, reclining seats and cup holders in the armrests?

BUILDINGS

Above: Meder house, 308 North Nevada Street, built circa 1875. *Courtesy of the Nevada State Library and Archives.*

Right: "The Hank Monk Schottische" composed by J.P. Meder, 1878. *Courtesy of the Special Collections Department, University of Nevada–Reno Libraries.*

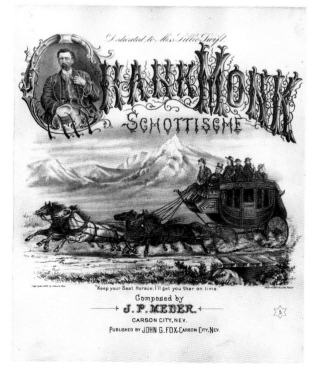

Left: Grave of Hank Monk (1826–1883), Lone Mountain Cemetery. *Photograph by the author.*

Below: Carson City Civic Auditorium, 813 North Carson Street, built 1939. *Photograph by the author.*

Buildings

There is an entertainment-related historic building in Carson City that survives to this day—the red brick Civic Auditorium situated at 813 North Carson Street. This Romanesque Revival building designed by Reno architect Lehman A. Ferris was a Depression-era public works project completed in 1939. According to the building's National Register of Historic Places nomination form (1990), initial specifications included a fifty- by seventy-foot dance floor, seating for five hundred, a twenty- by thirty-five-foot stage, cloak rooms, dressing rooms and a twenty- by seventy-foot banquet hall in the basement.

Also known as Municipal Auditorium, the building instantly became the venue of choice for many groups in town, including the American Legion, Boy Scouts and Carson City Band. The basement was used as the city/county library from 1965 to 1971. Interestingly, presidential candidate John F. Kennedy spoke here on January 31, 1960. Gradually, civic groups and organizations using the building found other places better suited to their needs, and in 1983, the building closed its doors.

In 1994, the Civic Auditorium became the Children's Museum of Northern Nevada, described as "a play-based learning experience created to inspire imagination and creativity." The interactive exhibits are designed to teach and reinforce state standards in the arts, sciences and humanities. The old Carson City Civic Auditorium was a place where people came to listen and learn—and play—and it is nice to see an adaptive reuse of the building for much the same purpose.

PART IV
PEOPLE

CARSON'S FIRST PEOPLE: THE WASHOE

It may sometimes be easy to forget that this was once Washoe country. Measuring and dividing the land into parcels was a foreign concept to this indigenous people. What did it matter that Lake Tahoe was 120 degrees west of the Royal Observatory in Greenwich, England? For millennia, they moved about their ancestral territory, which centered on Lake Tahoe and adjacent valleys to the east, including Eagle Valley and the site of Nevada's capital city. The Washoe ranged widely during their seasonal rounds of hunting and gathering, and relations with their neighbors—Maidu and Miwok to the west and Paiute to the east—were generally friendly and tribal boundaries fluid. Life for the Washoe followed a pattern, or cycle, intimately attuned to their diverse homeland.

The *Wa She Shu*, their traditional name for the entire tribe, later shortened to Washoe or Washo, had worked out a fundamental adaptation to the land and its resources whereby their calendar year was divided into thirds. In the spring and summer, people moved from their winter villages in the valleys east of the Sierra, and fishing season began. The center of their summer universe was Lake Tahoe, whose name is derived from the Washoe phrase *Da ow a ga*, meaning "edge of the lake." Late summer and fall was harvesting season, and the Washoe returned to their eastern valleys and mountain ranges beyond, especially the Pine Nut Range for piñon harvest. The third significant season in Washoe subsistence-settlement was the hunting season, which took place year-round but became especially important in the fall and early winter. In the spring, the world renewed, and the cycle began again.

The world rushed in, and in a generation, life for the Washoe and other Native Americans of the Sierra Nevada and western Great Basin would never be the same. That deluge of newcomers, of course, was a consequence of the 1849 California Gold Rush, and a decade later, the lure of the Comstock Lode beckoned. Ironically, the latter inundation of eager argonauts to the piñon juniper–clad slopes of the Virginia Range was known as the "Rush to Washoe," the tribal name being applied to the region. From the Washoe perspective, this amounted to nothing less than an invasion. Jo Ann Nevers, in her book *Wa She Shu: A Washo Tribal History* (1976), said as much: "At first, most of these invaders passed through the area and continued on to the gold fields in California. Later, many returned to Washo valleys to steal the area's valuable resources and fertile land from the Washo."

The miners of the Comstock displaced the Washoe and forever altered their age-old system of subsistence-settlement, and the ripple effect extended to Lake Tahoe as well. The old-growth forests and abundant fisheries of the Washoe's sacred lake succumbed to the axe and fishhook of the newcomers. This happened years before the conservation movement, to say nothing of the land rights of native peoples. By the turn of the twentieth century, after the boomtown of Virginia City went bust and Tahoe became a playground for the wealthy of San Francisco, the Washoe found themselves as strangers in a strange land.

Focusing in from the wider Washoe territory to Carson City proper, historians point to two almost diametrically opposed cultural survivals associated with the capital city; one is an artist and the other an institution. The artist, a Washoe woman and Carson City resident named Louisa Keyser or, more famously, Datsolalee (circa 1850–1925), was the personification of the ancient Washoe art of basket weaving. The institution was the Stewart Indian School, located on the southern outskirts of Carson City. Unlike Datsolalee and others like her who worked to preserve Washoe cultural heritage, the Stewart Indian School attempted to enforce assimilation into white society and discourage any Native American identity among its students. Visitors to Nevada's capital city often encounter both—the collection of Datsolalee baskets at the Nevada State Museum and the largely vacant buildings of the old Stewart Indian School—and are left to ponder the contrast they represent.

Datsolalee, whose given name was Dabuda, was born in the vicinity of Woodfords in the Carson Valley around 1850. She worked as a domestic servant in an eastern California mining camp and on a Carson Valley ranch, where she met and married her second husband, Charlie Keyser, in

People

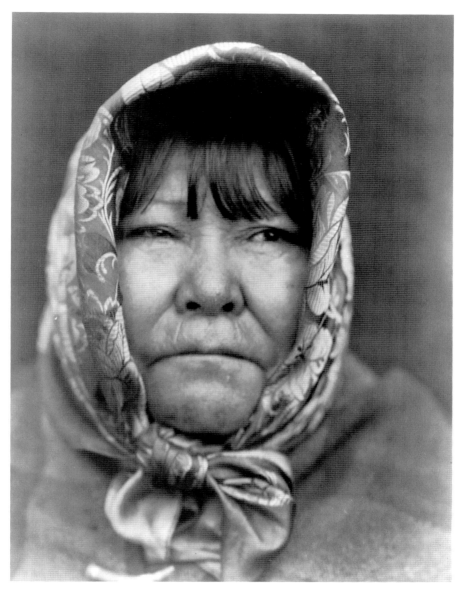

Louisa Keyser (circa 1850–1925), also known as Datsolalee. *Courtesy of the Library of Congress.*

1888. (Dabuda's first husband and their two children had died long before then.) In 1895, Carson City merchant Abe Cohn noticed her beautiful handiwork and offered to sell any baskets that Louisa, her adopted English name, could produce.

The basketry, constructed of finely split willow bark, redbud and bracken fern and decorated with interwoven, often geometric, designs, became an instant sensation. Around the turn of the twentieth century, Americans became nostalgic for the frontier, and items of Western and Native American material culture became highly collectible. As art historian Marvin Cohodas explained in *Tahoe: A Visual History* (2015), "Decorating an 'Indian Room' or parlor with Native American objects was an important status symbol for middle-class families at this time [1890–1908], with Navajo weavings, Pueblo pottery, and western baskets particularly desirable."

Abe Cohn and his wife, Amy, not only sold Louisa's baskets in their Carson City store, the Emporium Company, they became both provider and promoter as well. Louisa and Charlie Keyser settled into a small cottage at 331 West Proctor Street right next door to the Cohns' house. It was a reciprocal arrangement; the Keysers received food, clothing, shelter and medical care from their patrons, the Cohns, in exchange for baskets. In the summertime, the two couples lived up at Tahoe City on Lake Tahoe's north shore, where Louisa, who in 1899 began going by the nickname Datsolalee, would weave her magic outside the Cohns' shop, the Bicose, to the delight of well-to-do Tahoe tourists.

Datsolalee passed away in 1925, having produced perhaps as many as three hundred baskets while working for the Cohns. In a recent exhibit at the Nevada Museum of Art in Reno (August 22, 2015, to January 10, 2016), the public got a rare treat: the largest number of Datsolalee baskets from public and private collections ever assembled in one place. To see one or several of her baskets is memorable, but to see a room full is an experience of a lifetime. Datsolalee is buried in the Stewart Indian School Cemetery in Carson City.

The Stewart Indian School on Snyder Avenue in Carson City provided for the educational needs of Native American children—especially Nevada's Washoe, Paiute and Shoshone—from 1890 to 1980. Although initially called the Clear Creek Indian Training School, its eventual name honors William M. Stewart (1827–1909), who served as U.S. senator from Nevada for nearly thirty years. The Stewart Indian School was one of some two dozen non-reservation schools operated by the U.S. Bureau of Indian Affairs across

PEOPLE

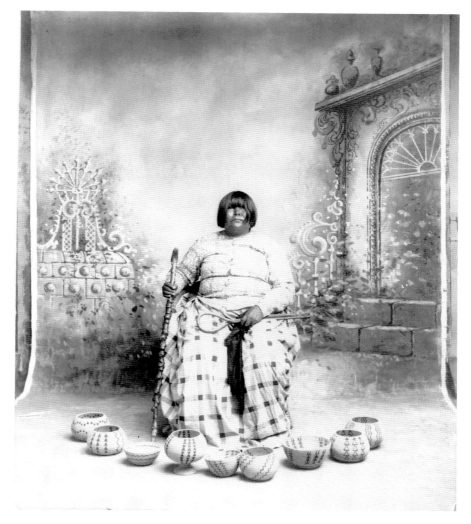

Louisa Keyser (Datsolalee) with baskets, circa 1899. *Courtesy of the Library of Congress*.

the country. The model for these coeducational boarding schools was the Carlisle Indian Industrial School in Pennsylvania.

Indian schools were almost paramilitary in their appearance and operation and had as part of their agenda the assimilation of Native American children into mainstream American culture. In a policy that lasted until 1934, students were prohibited from speaking their native languages and otherwise outwardly expressing their cultural identity. Many Washoe students, however, were not boarders because they lived locally, so their

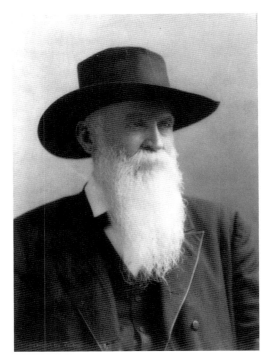

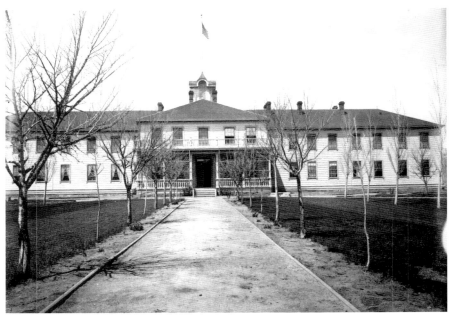

Left: U.S. senator William M. Stewart (1827–1909), circa 1897. *Courtesy of the Library of Congress.*

Below: Stewart Indian School Administration building, circa 1890. *Courtesy of the Nevada State Library and Archives.*

People

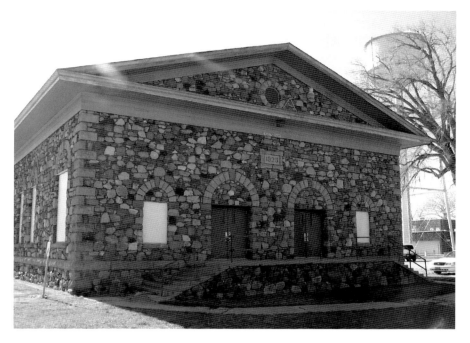

Stewart Indian School Auditorium. *Courtesy of the Nevada State Historic Preservation Office.*

experience was only a partial culture shock. Nevertheless, they were still expected to conform to the rules when on campus.

The curriculum focused on vocational training for boys and home economics for girls. In the early years of the school, students were expected to work at many jobs that would otherwise be the responsibility of a paid staff. The boys maintained the grounds, cared for the school's herd of livestock, worked in the carpentry and harness shops and did a considerable amount of stonemasonry. The girls did the school's laundry, worked in the kitchen and dining room and performed myriad other cleaning chores. It was not uncommon for students to spend half their day outside the classroom performing this work.

Students at the Stewart Indian School, like other secondary schools nationwide, took part in extracurricular activities—the school newspaper, band and various sports teams. Athletics, as Richard Moreno pointed out in *A Short History of Carson City* (2011), were both popular among students and successful in the statewide arena: "While relatively small in size, the school managed to win several state championships, including a 1916 state football

title, seven consecutive state 'AA' cross-country championships in the 1970s, and the 1966 state 'A' basketball championship."

The Washoe tribe is still a vital presence in Carson City, Carson Valley and their beloved Lake Tahoe. The annual Father's Day and Nevada Day powwows in Carson City are eagerly awaited and well-attended events that honor their heritage and traditions, express pan-Indian solidarity and are open to all in a spirit of unity. Part of the Stewart Indian School campus is now an interpretive center operated by the Nevada Indian Commission. Interestingly, images of Washoe basketry are etched in a wall along a newly opened section of I-580/US 395 for travelers between Carson City and Lake Tahoe to admire. Although the world has changed dramatically since explorer John C. Frémont and his guide Kit Carson first ventured into Washoe territory, the fabric of native society remains an important component of the tapestry that is Carson City, Nevada.

FROM GREAT BRITAIN TO THE GREAT BASIN

Robert Fulstone (1841–1931) came to Carson City with his parents and siblings in 1858 and remained there until his death in 1931. His biography should interest anyone with a penchant for Nevada history. Fulstone witnessed an enormous span of time—from the 1859 discovery of the Comstock Lode and the "wild and woolly" days of early Nevada described by Mark Twain and others to the stock market crash of 1929 and the onset of the Great Depression. Apparently, Robert Fulstone was never bitten by the gold bug, and he remained a local farmer and entrepreneur his entire career. His story is compelling for a number of reasons, not the least of which is that he was one of many unsung middle-class citizens of Carson City. Were it not for the accident of finding the archaeological remains of his farm off Lompa Lane, described in some detail in the author's *Nevada Historical Society Quarterly* article (see selected bibliography), his biography might yet remain limited to what appears on his gravestone in Lone Mountain Cemetery.

The immigration of the Fulstone family to the United States in the flush years of the early 1850s and their eventual participation in the rush west reflects the forces of demographic movement then existing at the international level. Social scientists frequently speak of human population movement in terms of "push-pull" factors, and the spatial and temporal parameters of the Fulstone migration are consistent with larger population trends on both sides of the Atlantic.

Robert Fulstone (1841–1931), 1881. *Courtesy of the Nevada Historical Society.*

England, the Fulstone ancestral home, was, in the second quarter of the nineteenth century, experiencing the world's first population explosion, prompted by the Industrial Revolution. The population of England, especially in the Midlands and London, increased dramatically because of a sudden decrease in the death rate. Despite our conception of mid-nineteenth-century urban-industrial England as Dickensian—a human warren choking with coal smoke and soot—it offered a substantially improved quality of life in terms of health and nutrition. A steady factory job in a town or city meant a reliable income with which to buy food and better access to healthcare. Proportionally more people lived to reproductive age. The demographic push produced by this population explosion was massive emigration; England sent forth its excess to populate and administer the British Empire. Many émigrés regarded the youthful, prosperous and geographically burgeoning United States as a prospective homeland—a definite pull factor.

Although economic push-pull factors may have influenced the Fulstone decision to come to the United States, it appears their conversion to the Mormon faith and its attendant call for the peopling of Deseret provided the primary lure. The family sailed from Liverpool aboard the *Charles Buck* on January 17, 1855, and disembarked at New Orleans two months later. The family traveled up the Mississippi River to St. Louis, arriving sometime in March, where they joined a Mormon Emigration Company wagon train bound for Utah Territory. The ten-month odyssey of Henry Fulstone Sr., wife Elizabeth and their two daughters and four sons ended with their arrival at Box Elder, Utah, in October 1855.

According to Fulstone family records, the overland portion of their journey was particularly difficult. Most of their possessions were lost or destroyed in transit. The next two and a half years were spent making a livelihood within the context of the Mormon faith, presumably in some agricultural capacity. In the spring of 1858, the Fulstones left both the Mormon Church and Box Elder, placing all of their material possessions in several wagons and crossing

to the opposite side of the Great Basin. They arrived in Eagle Valley in June and took up residence in the newly platted Carson City, which would become the territorial and then state capital. Henry Fulstone Sr. (1805–1897) opened a shoe shop on King Street, and the children eventually dispersed to both Washoe Valley to the north and Carson Valley to the south.

Henry Fulstone Jr. and his brother Robert acquired land in the vicinity of the Carson Hot Springs. Henry and his wife built a house south of the hot springs, while his bachelor brother Robert built his house along McDonald's Toll Road in 1862. After Henry's wife died in 1868, he moved to Washoe Valley, leaving the operation of the farm in Robert's hands. The 1870 Ormsby County Assessment Rolls listed Robert Fulstone as being liable for taxes on property amounting to 520 acres. In addition, the county assessed Robert Fulstone for this property: two wagons, three horses, twenty-six cows, twenty head of stock cattle and eighteen tons of hay. The precise location of a dairy that Henry Jr. and Robert jointly operated is unknown, but in all likelihood, it was situated near the hot springs.

When Robert Fulstone built his house along the McDonald's Toll Road in 1862, the Rush to Washoe was on. Only three years earlier, Nevada had been, in Robert Laxalt's words, "simply a place to be gotten through as quickly as possible on the way to golden California." Then silver was discovered on the slopes of Mount Davidson (a.k.a. Sun Mountain) in 1859, and one of the greatest mining booms in history commenced. With the boom came a demand for all sorts of agricultural produce. According to Thompson and West's *History of Nevada* (1881), "It was not until the discovery of the rich silver mines of the Comstock Lode that the [agricultural] producing power of any part of the State was tested. When Gold Hill, Virginia City, Dayton, and other towns, sprang into existence with their inevitable extravagant as well as necessary wants, fruits, vegetables, and all kinds of perishable produce, were worth mints of money." This stimulated agriculture on both sides of the Sierra Nevada range, and it appears that young Robert Fulstone saw an opportunity to turn milk into gold.

Of particular interest to Robert Fulstone's participation in this sector of the economy is the origin and growth of the dairy industry in Nevada. There were only 6,174 dairy cows in all of Nevada according to the decennial census of 1870, so his modest 26 milk cows probably meant he could sell all the milk and butter he could produce. Prior to rapid and efficient refrigerated transport, dairy products were, of necessity, produced near their point of consumption, and Fulstone's dairy was well situated with respect to this market.

Robert Fulstone's house entered the archaeological record on July 11, 1871. According to the Carson City *Daily State Register* newspaper account of the incident, Robert and his younger brother Joe had been working in the field that day. Joe went back to Robert's house around noon to start a fire for lunch and returned, but when they looked back a short while later, the house was engulfed in flame. The site was never reoccupied, and unfortunately, no photograph of Robert Fulstone's house or farm is known to exist.

For fifteen days during August 1994, a team of archaeologists conducted field investigations at the site of Robert Fulstone's farmstead. This effort, which was funded by the Nevada Department of Transportation because the site was squarely in the path of the then proposed I-580 Carson City bypass, resulted in the removal of more than thirty cubic meters of soil, which yielded in excess of fifteen thousand historic artifacts.

With the exception of three old fence posts, no structural remains of the farm existed above ground. The most noteworthy subsurface discovery was that of the cellar hole, which contained kitchen-related items such as pots and pans, plates, bowls and cutlery. Architectural remains consisted of hundreds of cut nails, chimney bricks and pieces of window glass. Other objects of interest included currency (1838 and 1852 dimes), buttons, a penknife and a large grinding stone. All of these objects are presently curated with the Nevada State Museum in Carson City.

Based on the analysis of material remains of this site, it is possible to say that Robert Fulstone probably enjoyed a fairly comfortable lifestyle. Many of the items recovered are utilitarian, such as buttons from work clothes, tools and functional pots and pans—the things one would expect a bachelor farmer to possess. On the other hand, Robert Fulstone also appeared to have enjoyed some of the finer things. Several buttons belonged to more elegant articles of clothing, such as fancy vests and gloves. Leaded crystal drinking glass and decanter fragments and the remains of a large set of china indicate that he may have entertained. In addition, the nearly two thousand bottle-glass fragments suggest that he enjoyed wine and champagne but did not have a taste for hard liquor.

The level of affluence to which the material remains attest is corroborated by an examination of the 1870 Ormsby County Tax Assessment Rolls. When the listing of Robert Fulstone's personal property is compared to those of fifty individuals who surround him on the tax rolls, admittedly a crude measure of relative wealth, his personal property valued at $2,400 is clearly above the average of only $747. Expressed differently, it appears that this young man, having arrived in a fledgling Carson City, had become relatively successful.

People

Left: Robert and Mary (McCue) Fulstone, married in 1875 in Carson City. *Courtesy of Norma Jean Hesse.*

Below: Graves of Robert and Mary Fulstone, Lone Mountain Cemetery, Carson City. *Photograph by the author.*

Fulstone Family Park on Northridge Drive near the site of Robert Fulstone's farmhouse, which was destroyed by fire on July 11, 1871. *Photograph by the author.*

This success was probably due to a combination of his own personal industry and the fact that his business—supplying the Comstock with meat and dairy products—was one for which he was doubtless well rewarded.

The year after the conflagration that destroyed his house, Robert accompanied his brothers to Modoc County, California, but he returned to Nevada after a particularly hard and discouraging winter. In 1875, he married Mary McCue in Carson City. About this time, he was a member of the Masonic Lodge in Genoa and owned property on the corner of King and Thompson Streets in Carson City, just one block from his father. Later, around the turn of the century, Robert and Mary are known to have resided in Lovelock, Nevada, where Robert either worked for or was the proprietor of Young's Hotel.

A few years thereafter, the Fulstones returned to Carson City, where they lived out the rest of their lives. Robert died in 1931; he is buried in the Lone Mountain Cemetery, approximately one mile from his 1860s farm, alongside his wife, parents, several siblings and other family members. A park near his former farmhouse is now the municipal Fulstone Family Park.

LITERARY CARSON CITY

Carson City has a rightful place in the American literary landscape—for many readers, this may come as something of a surprise. Large cities like New York and San Francisco are known for their writers-in-residence, and many books, such as Eric Maisel's *A Writer's San Francisco* (2006), attest to this association. Small towns and small cities have their writers, too: John Steinbeck's Salinas, California, being a case in point. But what writers have put Carson City on a literary map? There are actually more than you may think, but here are two of Carson City's best known and well loved men of letters.

Samuel Langhorne Clemens (1835–1910), whose nom de plume Mark Twain is universally recognized, has an early and intimate association with Carson City. He came to the newly designated capital of Nevada Territory in August 1861 because his elder brother Orion had been appointed by President Abraham Lincoln to serve under Governor James Nye as territorial secretary. Sam had hoped he could work for his brother in some capacity, but as it turned out, money in the fledgling territory was in short supply—and besides, there was no position of secretary to the secretary. In spite of this disappointing setback, Sam was happy to be out west; had he stayed back in his home state of Missouri, he most certainly would have gotten more involved in the brewing hostilities of the American Civil War. (Sam Clemens actually spent two weeks in a Confederate regiment before opting to move west.)

Sam Clemens remained in Nevada Territory for nearly three years, leaving for San Francisco in May 1864 once he had successfully made a name for himself as a newspaper reporter and storyteller par excellence. Although no stranger to the newspaper business—he had worked for various newspapers in Missouri and Iowa as a young man—it was while in Nevada that he found his voice as a writer. After a year of trying his hand at mining and a stint up at Lake Tahoe, Sam landed a job as cub reporter for the *Territorial Enterprise*, a preeminent paper in booming Virginia City. The paper initially gave him the assignment of covering the territorial legislature in Carson City, a perceptive decision considering Sam's fraternal connection with the territorial secretary.

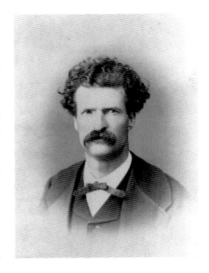

Samuel Langhorne Clemens, also known as Mark Twain. *Courtesy of the Library of Congress.*

When in Carson City, Sam Clemens would frequently stay with his brother Orion, Orion's wife, Mary "Mollie," and the couple's daughter, Jennie. The Orion Clemens house, built in early 1864, is one of the architectural gems of Carson City's west side historic district. By the time Sam stayed in this house on the corner of Spear and Division Streets, he had become Mark Twain, attaching for the first time the pen name to correspondence submitted to the *Territorial Enterprise* on January 31, 1863. According to scholars, this is the earliest known example of the author's name in print, and Carson City is rightfully proud of its "birthplace," so to speak.

Mark Twain's time in Nevada is best documented in his humorously autobiographical book *Roughing It* (1872). Among his many adventures and escapades in the West, it includes substantial sections on his time spent in Virginia City, Carson City and Lake Tahoe. Here is Twain's impression of Carson City upon arrival in 1861:

> *By and by Carson City was pointed out to us. It nestled in the edge of a great plain and was a sufficient number of miles away to look like an assemblage of mere white spots in the shadow of a grim range of mountains overlooking it, whose summits seemed lifted clear out of companionship and consciousness of earthly things.... We arrived, disembarked, and the stage*

went on. It was a "wooden" town; its population two thousand souls. The main street consisted of four or five blocks of little white frame stores.... They were packed close together, side by side, as if room were scarce in that mighty plain.

The narrative continues for many pages, of course, with humorous asides such as a description of a local meteorological phenomenon—a powerful wind known affectionately as the "Washoe Zephyr." Twain eventually moved back east, spending his most productive years—the era known as the "Gilded Age," a term he coined—in Hartford, Connecticut, and Elmira, New York, where he penned his classics: *The Adventures of Tom Sawyer* (1876), *The Prince and the Pauper* (1881), *Life on the Mississippi* (1883), *Adventures of Huckleberry Finn* (1884) and *A Connecticut Yankee in King Arthur's Court* (1889), among others.

Despite his caustic wit and inclination toward satire, Twain was a sentimental soul who once said, "The secret source of humor itself is not joy but sorrow." He certainly had his share of sorrow insofar as his wife, Olivia, and three of their four children predeceased him. Twain grieved while in Carson City, too; his nine-year-old niece, Jennie, died of spotted fever on

Orion Clemens house, 502 North Division Street, built 1863–64. *Courtesy of the Nevada State Library and Archives.*

February 1, 1864. As Cindy Southerland explained in *Cemeteries of Carson City and Carson Valley* (2010), "Jennie's sandstone marker was cut from Curry's quarry. In her honor, the Nevada legislature adjourned so members could attend her services [in what is now Lone Mountain Cemetery]. Her uncle's grief would soon find an outlet in a published lashing of the undertaker in charge of Jennie's funeral."

Robert Laxalt (1923–2001) is best known for his book *Sweet Promised Land* (1957), a moving story about accompanying his father on a trip to his natal Basque country. It concludes with Laxalt's father's realization that he had become an American and is considered a classic in the literature on the immigrant experience in America. Robert Laxalt's parents emigrated from a Basque province of the French Pyrenees, and like many of his compatriots, Dominique Laxalt (1886–1971) made a living as a sheepherder in the mountains of western Nevada and eastern California. Robert's mother, Theresa (1891–1978), kept the home fires burning while operating a boardinghouse in Carson City, which became the subject of another wonderful book, *The Basque Hotel* (1989).

For many readers, Laxalt's *The Basque Hotel* is to Carson City what Walter Van Tilburg Clark's *The City of Trembling Leaves* (1945) is to Reno. Both are works of fiction but thinly veiled autobiography, and they give readers a real sense of what their respective cities were like in years past. Here, for example, is Laxalt's evocative beginning to *The Basque Hotel*.

> *Along the length of Main Street, the business people of Carson City had come out to sweep the sidewalks in front of their shops and stores and little hotels. They did this when the sun had barely cleared the desert mountains to the east with a blinding burst of light, and before it had time to bake the sidewalks to a furnace heat.*

For those curious to know the location of the actual French Hotel, it was on the east side of North Carson Street between Telegraph and Proctor. As of this writing, the space is occupied by a Thai restaurant, The Basil.

Laxalt credits his mother for launching a distinguished literary career. One day, she brought home a typewriter for her children to use to write their school papers. Robert latched onto it immediately; he had found his medium, as he explained in his last book, *Travels with My Royal* (2001). Laxalt also credited his "second home," the Nevada State Library in Carson City, for giving him access to a world full of books. After graduating from the University of Nevada in 1947 with a BA in English, he became the Nevada

People

Right: Grave of Jennie Clemens (1855–1864), Lone Mountain Cemetery. *Photograph by the author.*

Below: Robert Laxalt (1923–2001), publicity photograph for *The Basque Hotel*, 1989. *Courtesy of the Special Collections Department, University of Nevada–Reno Libraries.*

correspondent for United Press International (UPI), the *Wall Street Journal* and the *New York Times*. He also wrote numerous articles for *National Geographic*. Robert Laxalt's appointment in 1954 as director of news and publications for the University of Nevada–Reno, a position he held until 1983, proved significant for both the university and for the world of publishing; he founded and served as the first director of the University of Nevada Press. In 1988, he was inducted into the Nevada Writers Hall of Fame.

Nevadans know Robert Laxalt as the literary brother of Nevada governor and U.S. senator Paul Laxalt. Like Samuel Clemens, whose brother Orion Clemens served as Nevada territorial secretary in the early 1860s, writing and politics make for an interesting combination. The Basque trilogy about the Laxalt family, which begins with the aforementioned *The Basque Hotel* and includes *Child of the Holy Ghost* (1992), concludes with *The Governor's Mansion* (1994), a nominally fictional account of the 1966 gubernatorial race. Robert Laxalt worked on his brother's campaigns, but he preferred to remain on the political sidelines.

Nevada's Laxalt family is one of those rags-to-riches stories, but it is not about the wealth. One could look at the number of Laxalts in professional life and conclude they successfully assimilated into American society. Not to diminish the accomplishments of an immigrant family whose first home was a dirt-floored cabin in the Sierra only to occupy the Governor's Mansion

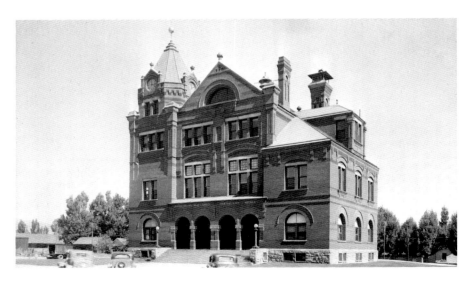

Former U.S. Post Office and Federal Courthouse, 401 North Carson Street, completed in 1891, now the Paul Laxalt State Building. *Courtesy of the Library of Congress.*

within a generation, their true wealth, as Robert Laxalt well knew, was that they had found a place to call home. Robert Laxalt's affection for Nevada and for the Basque people who moved to this brave new world permeates his work, both literary and otherwise. In addition to being an authority on Basque culture in the West and producing an impressive body of literature—fiction and nonfiction alike—he educated his fellow Nevadans and others about the Basque people who are such an integral part of the state's cultural mosaic. In recognition of his decades of devotion to the Basque people, the City of San Sebastian, in the Spanish portion of Basque country, presented him with the *Tambor de Oro* award in 1986, something that he said meant more to him than book royalties or rave reviews.

There are other authors who have lived, or currently live, in Carson City, and they rightfully deserve a place in the capital city's literary landscape alongside Mark Twain and Robert Laxalt. For example, the fantasy writer David Eddings, who passed away in 2009, lived on Bonanza Drive. Eddings did not write about Carson City, however. Instead, his more than two dozen novels are more akin to Tolkien than Twain.

THE TEACHER, THE INVENTOR AND THE SCIENTIST

For such a small place, Carson City has had perhaps more than its share of talented individuals. Their collective biographies deserve book-length, or encyclopedic, treatment. Three of those gifted people—Hannah K. Clapp, George W.G. Ferris Jr. and Charles W. Friend—are the subject of this chapter. Although they all left their mark on Carson City, their accomplishments went well beyond Nevada's capital.

Hannah Keziah Clapp (1824–1909) was a pioneer in more ways than one. A native of Albany, New York, Clapp accompanied her brother and his family to Carson City in 1860. At that time, western Nevada was still part of Utah Territory, and Carson City was a tiny settlement along the Bonanza Road. She did not arrive without skills, however. Hannah Clapp was a trained teacher and school administrator, having received her education at Union Seminary in Ypsilanti, Michigan, followed by several years of teaching and serving as principal of the Female Seminary in Michigan's state capital.

In November 1861, the Nevada Territorial Legislature passed a bill chartering a school for Carson City. The city's first school was called Sierra Seminary, and Hannah Clapp was instrumental in the creation of a successful coeducational curriculum. Its less formal name was Miss Clapp's School. A large percentage of the student body came from prominent families who had moved to the capital city either because of political appointment or because of opportunities the territorial, and later state, capital had to offer. One of Miss Clapp's students, for example, was territorial secretary Orion

People

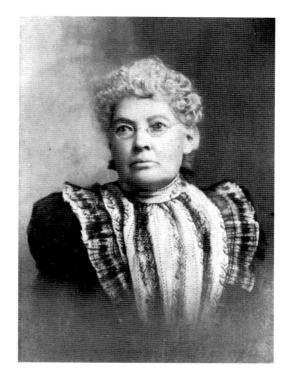

Right: Hannah K. Clapp (1824–1909). *Courtesy of the Special Collections Department, University of Nevada–Reno Libraries.*

Below: Hannah Clapp house, also known as the T.B. Rickey house, 512 North Mountain Street, built 1870. *Photograph by the author.*

Clemens's daughter, Jennie. The Sierra Seminary operated as a private school until 1886.

In addition to being a talented educator, Hannah Clapp was an entrepreneur—it was a rare thing in those days for a woman to be in business. The story of how she and her partner Eliza C. Babcock successfully bid on a contract to construct an iron fence around the state capitol is told to this day. Some say she hoodwinked state officials by only using her initials H.K. Clapp, thus disguising her gender, but this story has been discredited as folklore without any basis in fact. In reality, Clapp and Babcock got the contract because they submitted the lowest bid, and the fence they subsequently constructed was, and is, beautiful. It remains a testimony to Hannah Clapp's ability to build more than student achievement.

Hannah Clapp eventually left Carson City and moved to Reno to become part of the newly relocated (from Elko) campus of the University of Nevada. There she served as instructor of English and history, managed the women's dormitory and became the school's first librarian. She remained at the university from 1888 until her retirement in 1901. While there, Clapp was an outspoken advocate for women's voting rights, but unfortunately, she would not live to see that suffragist dream become reality. Women could not vote in state elections until 1914, and not until 1920 could they vote in federal elections. Nevertheless, Hannah K. Clapp possessed a pioneering spirit epitomized by the popular western song "Don't Fence Me In," and she continues to inspire Nevadans, male and female alike.

George Washington Gale Ferris Jr. (1859–1896), like many inventors, may not be as well known as the thing that bears his name: the Ferris wheel. Although George Ferris Jr. was born in Galesburg, Illinois, he spent most of his childhood in Nevada. Ferris's father, George W.G. Ferris Sr., moved the family to Carson Valley and then to Carson City when George Jr. was only five. He grew up in a house on West Third Street, now known as the Ferris Mansion and part of the Kit Carson Trail through the west side historic district. The senior Ferris owned a successful landscaping business, and many of the trees he planted in Carson City are still alive and well, including a blue spruce on the grounds of the state capitol.

Instead of following in his father's footsteps as a landscaper or establishing his own business venture in Carson City, George Ferris Jr. became an engineer. For his formal education, he first attended the California Military Academy in Oakland followed by Rensselaer Polytechnic Institute in Troy, New York, where he graduated with a degree in civil engineering. His specialty was working with structural steel, a construction material that was becoming

People

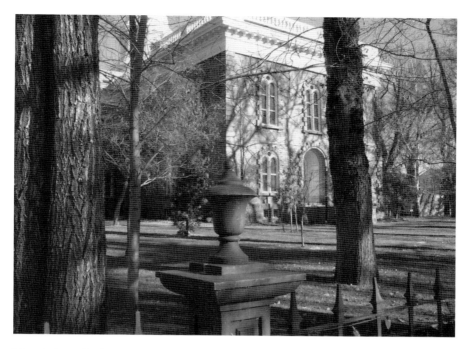

Nevada State Capitol and grounds with Hannah Clapp's fence in the foreground. *Photograph by the author.*

increasingly popular at the time. After forming his own company and designing his share of bridges, trestles and the like in the growing industrial corridor between New York and Chicago, his professional reputation soared. He even had an office in Pittsburgh, the epicenter for everything steel.

The Ferris wheel, that ubiquitous feature of amusement parks worldwide, originated with the City of Chicago's desire to raise the bar set by Paris. Chicago had been selected as the site of the 1893 World's Columbian Exposition, more commonly referred to as the Chicago World's Fair, and the organizers realized they had to showcase an engineering marvel, one that would rival the Eiffel Tower, which had been constructed for the 1889 Paris International Exposition. The lead architect, Daniel Burnham, selected Ferris's proposal of the "Chicago Wheel."

The design of Ferris's wheel was impressive indeed, its scale enormous. The thing rose to a height of 264 feet, and its thirty-six gondolas were capable of giving more than two thousand people a ride at the same time. Some engineering colleagues had serious doubts as to whether it would collapse under its own weight, let alone rotate, smoothly or otherwise, on

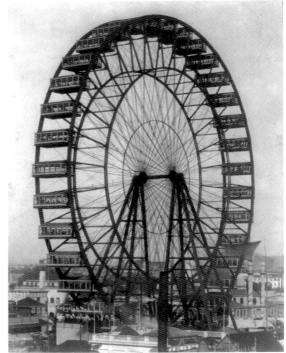

Above: Ferris Mansion, 311 West Third Street, built 1869. *Courtesy of the Library of Congress.*

Right: Ferris wheel at the Chicago World's Fair, 1893. *Courtesy of the Library of Congress.*

its axle. Ferris assured his detractors that his invention would not only work as planned, but it would fulfill expectations as the centerpiece of the fair as well. According to the Chicago Architecture Foundation, "For many, the Ferris wheel took them as high up as they'd ever been—and the views did not disappoint. As passengers traveled through the air, they could see out over Lake Michigan and glimpse new vistas of the city itself."

Unfortunately, the wheel invented by the boy who grew up in Carson City did not result in financial gain. In fact, some have said it ruined him. He turned down potentially lucrative engineering projects in order to devote time to his wheel. His business and his marriage suffered as a consequence. Up until the day he died in 1896, George W.G. Ferris Jr. was trying to build a better mousetrap, as they say. It is nice to think, however, that he would be gratified to know his invention—the Ferris wheel—makes an occasional appearance at Mills Park in Carson City whenever the carnival comes to town.

Charles William Friend (1835–1907) was Carson City's man of science for many years. He had an almost insatiable curiosity about the natural sciences—meteorology, climatology, seismology and astronomy. People traveling past his house on Stewart Street must have paused in amazement at the unusual sight of his observatory and weather station. How he found the time for all those hobbies was probably a frequently asked question. Charles Friend, after all, had a business over on Carson Street; he was a jeweler and optician.

A Prussian by birth, Charles Friend came to the western United States with his father during the California Gold Rush. Panning for gold did not suit him, so he found an apprenticeship with a jeweler and optician in the Folsom area. After he had sufficiently learned his trade, Friend moved to Carson City in 1867 and set up shop. His interest in optics understandably translated into a passion for astronomy. Eyeglasses to read by are really no different conceptually than a six-inch refracting telescope that allows one to explore the constellations. In 1875–76, Friend constructed a domed tower to house the aforesaid telescope, which he managed to borrow from the U.S. Naval Academy. Admittedly, the influence of his friend Senator William Stewart doubtless sealed the deal.

In 1880, Carson City had no means of weather forecasting other than getting occasional weather information from elsewhere via telegraph. Charles Friend had an acute awareness that local weather observations would benefit everyone, not just appeal to what are now called "weather geeks." Using instruments he either built or bought, he began taking

Charles W. Friend's observatory, corner of East King and Stewart Streets. *Courtesy of the Nevada Historical Society.*

regular observations, including temperature, barometric pressure, relative humidity, precipitation and wind speed and direction. In his book *Air Apparent: How Meteorologists Learned to Map, Predict, and Dramatize Weather* (1999), geographer Mark Monmonier explained that "networks of volunteer weather observers" were vital to a larger understanding of weather systems. Charles Friend, Nevada's first weatherman, became part of that network.

The Nevada legislature eventually realized that having accurate weather forecasts and climate data could have practical applications, especially for farmers and ranchers, and in 1887, the Nevada State Weather Service (NSWS) was created. Charles Friend was selected as director, with an annual salary of $600, and he held that position until his death in 1907. When he began taking observations at his Carson City home, his was the lone weather station in the state. Under his directorship, Nevada gained some three dozen more stations.

Earthquakes, of which Nevada has its fair share, also captivated Friend's scientific attention. Ever the recorder of natural phenomena, Friend installed a seismograph in the basement of the state capitol building. Now, the Seismological Laboratory at the University of Nevada–Reno, has responsibility for monitoring earthquake activity in the area. Charles Friend,

People

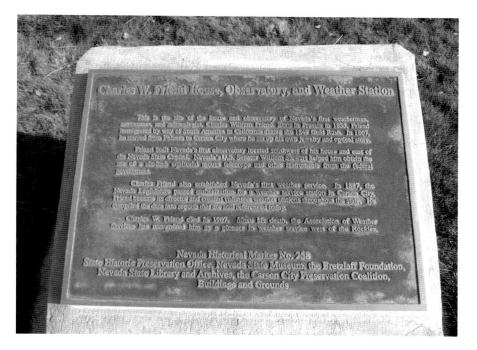

Plaque in Charles W. Friend Park, dedicated on October 30, 1999. Nevada Historical Marker No. 258. *Photograph by the author.*

it seems, was on the cusp between the era of the citizen-scientist and that of the modern agency or institution. Director Friend would be equally at home chatting with other polymaths or addressing the state legislature.

A brass plaque (Nevada Historical Marker No. 258) in the park on Stewart Street opposite the entrance to the Nevada State Library and Archives commemorates his life and work. It reads, in part, "This is the site of the house and observatory of Nevada's first weatherman, astronomer, and seismologist, Charles William Friend.... [T]he Association of Weather Services has recognized him as a pioneer in weather service west of the Rockies." The park, bounded by Stewart, Valley, East King and East Second Streets, is known as Charles Friend Park.

PART V
EVENTS

CARSON CITY HAS ITS FAULTS

On December 28, 2016, at 12:18 a.m., Carson City was rocked by an earthquake, followed by two sizable aftershocks within the hour. According to the Nevada Seismological Laboratory at the University of Nevada–Reno, the quake, which measured a magnitude 5.8, was centered southwest of Hawthorne, Nevada, approximately seventy-three miles southeast of Carson City. Residents of western Nevada are accustomed to the ground shaking fairly regularly; earthquakes happen here on a daily basis. Most are so minor they are not noticed.

It is useful to make the distinction between two terms often used to describe earthquakes, magnitude and intensity. According to the U.S. Geological Survey, "Magnitude measures the energy released at the source of the earthquake…[and] is determined from measurements on seismographs. Intensity measures the strength of shaking produced by the earthquake at a certain location…[and] is determined from effects on people, human structures, and the natural environment."

Since the 1850s, when newspapers in the region began to publish reports of earthquakes and the damage they caused, there have been more than a dozen temblors with an estimated or measured magnitude of 6.0 or greater. Among these intense earthquakes is one that struck at around 2:45 a.m. on June 3, 1887. According to an article published the following day in the *Territorial Enterprise*, Carson City buildings, including the state capitol, sustained damage in the form of chimneys toppling, plaster falling off and brick and stone walls cracking. Springs in the vicinity were said to have been

affected insofar as they either went dry or increased their flow. South of town, a fissure fifty feet long suddenly appeared, and mud and hot water spewed out for half an hour. Many Carson City residents, some clad only in bedclothes, sought sanctuary outdoors away from the hazard of crumbling structures. Seismologists who have studied this earthquake believe it was a magnitude 6.3 centered somewhere in Carson Valley.

The reason why Carson City is so vulnerable to earthquakes and experiences them regularly, is intimately connected to movement in the earth's crust. Geologists studying the zone they call the Sierra Nevada–Great Basin seismic belt attribute this movement to tectonic forces that are simultaneously stretching the crust apart and moving it in opposing directions. The result is a series of faults, cracks in the earth's crust, where vertical and/or lateral displacements occur. The movement is slow, maybe half an inch a year, but as pressure on opposing fault blocks builds, the eventual release of energy takes the form of an earthquake.

One consequence of this faulted landscape is a plethora of thermal springs in the area. Carson City has the two notable springs: the Carson Hot Springs in the north end of town and Warm Springs adjacent to the former Nevada State Prison. These are part of a pattern of hot springs that flank the eastern scarp of the tectonically active Carson Range. Wally's Hot Springs south of Genoa and Steamboat Hot Springs in south Reno are notable examples to the south and north of Carson City, respectively. The Steamboat Hot Springs, so named because of the plume of steam it sends out, achieved literary fame when it was described by Mark Twain in a letter to the *Territorial Enterprise* on August 25, 1863, later reprinted in his popular book *Roughing It* (1872), as well as in Dan De Quille's *The Big Bonanza* (1876). Other hot springs in the region associated with the Carson Range fault include Bowers Mansion (Franktown Hot Springs), Damonte, Zolezzi, Moana and Lawton Hot Springs.

Although earthquakes are rightly considered a hazard, the hydrothermal activity associated with faults in the area has been a blessing. The local Native American tribe, the Washoe, often camped near hot springs, particularly in the winter. Hot springs have been a source of recreation, and many residents and visitors alike extol the virtues of a good soak. Wally's Hot Springs in Carson Valley has been a popular resort for generations. Lastly, the famous Comstock Lode has hydrothermal activity to thank for its rich gold and silver deposits. These precious metal minerals were injected into the surrounding country rock of Mount Davidson through the conduits that cracks in the earth's crust provided. However, miners

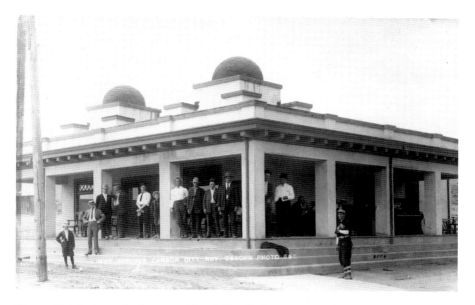

Carson Hot Springs, also known as Shaw's Hot Springs. *Courtesy of the Special Collections Department, University of Nevada–Reno Libraries.*

descending deep into mine shafts of the Big Bonanza often had to contend with hot temperatures and scalding water, as described by Eliot Lord in his book *Comstock Mining and Miners* (1883):

> *Even if men escaped the dangers of scalding and suffocation, they were exposed to another peril arising from the heat. The miners in the hot levels were subjected to most trying changes of temperature in ascending the shafts on the swift-moving cages. The passage of two thousand feet in winter was like a magical transfer from Guiana to Spitzbergen. In three minutes men who had been sweltering naked in a stifling atmosphere might be lifted up into the chill air of bleak hills where a snowstorm was raging.*

One need not go underground to appreciate the faulting in Carson City. A simple drive around town or stroll through the west side historic district will suffice. To the perceptive traveler, an abrupt change in topography is the first clue, and these abound in Carson City. Other indicators of a fault, as mentioned above, is a spring; running water and luxuriant vegetation in an otherwise parched landscape are surface manifestations of water welling up from deep below ground. A few places to observe Carson City's

fault system include the following: on South Curry Street behind the U.S. Forest Service Office and the Nevada State Railroad Museum; on the north side of South Minnesota Street in the historic district; on North Carson Street just north of Adele's Restaurant; and on East Long Street east of Roop Street. At first glance, these abrupt changes in topography, or what geologists call surface offsets, may seem like natural terraces that were perhaps carved away by some ancient river, but they are actually fault blocks that have shifted relative to one another, in some cases as much as thirty feet. Each block shift was doubtless accompanied by an earthquake.

Although most Americans immediately think of California's San Andreas Fault when the subject of earthquakes comes up, Carson City and its environs are equally vulnerable to "the big one." Carson City is centrally located along the Carson Range fault system, which extends along the east side of the mountains from Reno to Woodfords, California. According to a Nevada Bureau of Mines and Geology (NBMG) publication, *Planning*

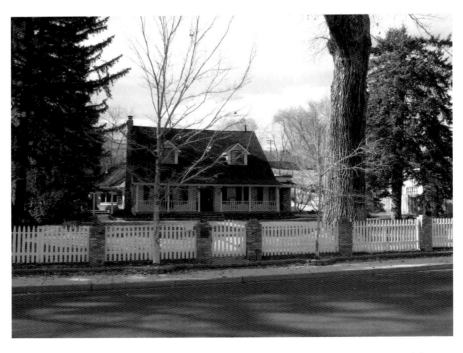

Earthquake fault zone, 710 South Minnesota Street. Note the height of land behind the house. *Photograph by the author.*

Events

Scenario for a Major Earthquake in Western Nevada (1996), "Large earthquakes will inevitably occur in western Nevada—only the timing is uncertain." This being Nevada, residents have asked about the odds, to which the NBMG has replied that there is a 50 percent chance of a magnitude 6.5 or greater earthquake striking the Reno–Carson City area in the next fifty years.

NEVADA DAY AND HALLOWEEN

Holidays are important to states and communities, and sometimes they are iconic to a place. Mardi Gras, for example, is a sanctioned holiday in Louisiana; state offices and schools are closed, and everyone celebrates Fat Tuesday. Some U.S. cities are known for their tradition of celebrating specific holidays: Boston's St. Patrick's Day; New York's Thanksgiving; Philadelphia's New Year's Day; and San Francisco's Chinese New Year. And the whole country, of course, celebrates the Fourth of July, Independence Day. Parades are the greatest form of public celebration where many holidays are concerned. They have many common denominators, such as spectators lining the parade route and entrants vying for attention and applause.

For Nevada in general, and Carson City in particular, October 31 is the biggest holiday of the year, and not just because it is Halloween. It is a state holiday because Nevada became the thirty-sixth state in the Union on October 31, 1864. In fact, Nevada Day, as it is called, is the largest celebration of statehood in the country. And yes, there are Nevada Day parades in many communities statewide, but the one in the state capital is the premier parade.

Nevada Day used to be called Admission Day, and there is a clear connection between that and the state's slogan, "Battle Born." The Civil War was ongoing, and President Abraham Lincoln was seeking reelection when he authorized the state's admission. The first real commemoration of Nevada's admission was in the 1870s in Virginia City, at the time the state's major metropolis. It was organized by a group called the Pacific Coast Pioneers. Journalist Alfred Doten (1829–1903) wrote the following

entry in his diary on October 31, 1873: "Grand celebration of the PCPs [Pacific Coast Pioneers] in honor of the Ninth Anniversary of the admission of Nevada into the Union—Procession came down from Pioneer Hall… escorted by National Guard with their band—Also Washington Guard Band and Mexican [War] Veterans in procession."

In 1908, a women's group based in Reno, the State Federation of Women's Clubs, lobbied unsuccessfully for the designation of Admission Day as a state holiday. It was not until 1933, however, that the state legislature passed a bill recognizing the Nevada Day holiday. For the most part, it remained synonymous with October 31 and Halloween until the new millennium, when the Nevada Day holiday was officially changed to the last Friday of October. The Nevada Day parade then moved to the Saturday following.

Although there were community parades on October 31 before the 1930s, such as those in Virginia City described by Doten, the first Nevada Day parade was in 1938. One of the initial boosters for holding this annual state celebration was Judge Clark J. Guild of Carson City. He and Thomas C. Wilson, an energetic advertising executive from Reno, enlisted the help of numerous clubs and organizations, including the Carson City Rotary and Lions clubs, and the 1938 event set the standard for all subsequent Nevada Day parades. The following year, the parade drew more than forty thousand spectators to the Carson Street parade route. With the exception of three years during World War II (1942, 1943 and 1944), many thousands of

Nevada Day Parade, Boys & Girls Club float, circa 1920s. *Courtesy of the Nevada Historical Society.*

Nevada Day Parade, Lions Club float. Photograph by John Nulty, 1963. *Courtesy of the Nevada State Library and Archives.*

people—spectators, entrants and concessionaires—have converged on Carson City ever since.

Some Nevada Day parades have been extra special, particularly those commemorating major anniversaries like the diamond jubilee (75th), centennial (100th) and sesquicentennial (150th). There are plenty of people who still vividly remember the 1964 centennial. Fifty years later, Guy Farmer wrote a piece for the *Nevada Appeal* in which he reflected on the centennial celebration. Among other things, he said, "The parade's grand marshals were the stars of the popular 'Bonanza' TV show: Lorne Greene, the family patriarch; Dan 'Hoss' Blocker; Michael 'Little Joe' Landon, and Pernell Roberts."

Today there are Nevada Day celebrations, including parades, in communities statewide. Carson City's celebration, however, is the main event; the governor always participates after hosting a pancake breakfast at the Governor's Mansion. Nevada Day is so important to the capital city that there is a standing committee with an executive director, board and staff, and planning the following year's event begins on November 1.

EVENTS

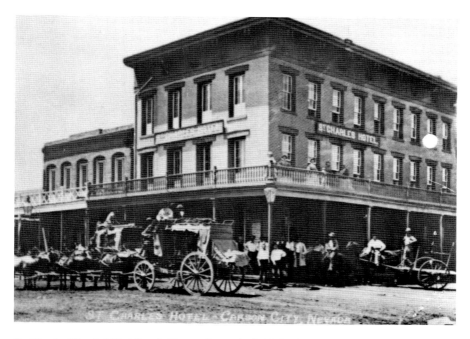

St. Charles Hotel, 302-4 South Carson Street, built 1862. Some people believe this old hotel is haunted; others contend the only spirits are in the bar. *Courtesy of the Nevada State Library and Archives.*

There is, understandably, a time-honored association between Nevada Day and Halloween. Along with Nevada's official colors of silver and blue, there is always plenty of orange and black decorating the streets, homes and businesses of Carson City at this time of year. In the weeks leading up to the end of October, many visitors and residents alike enjoy taking the docent-led Ghost Walk through the west side historic district. Since 1993, many homes that are not ordinarily open to the public, such as the Krebs-Peterson house, the Governor's Mansion, the D.L. Bliss Mansion and the Orion Clemens house, are on the tour. And in keeping with the Halloween spirit, there are occasional tours of Carson City's historic Lone Mountain Cemetery led by women appropriately dressed in nineteenth-century widow's weeds.

It seems there is one question on the mind of many Ghost Walk participants: "Is this building haunted and, if so, by whom?" Docents are well versed in the lore and legend of every place on the tour and delight in the retelling of a ghost story or two. One of those is Janet Jones, author of *Haunted Carson City* (2012). Another is Mary Bennett, director of Carson City's Ghost Walk, whose motto is "Supernatural Entertainment and Historical Folly."

PART VI
CORRIDORS

THE VIRGINIA AND TRUCKEE RAILROAD

There are no more railroad tracks in Carson City, except for those at the Nevada State Railroad Museum on South Carson Street. There was a time, however, when the railroad constituted a vital part of life in the capital city; residents set their clocks and watches by the train whistle, newspapers reported the arrival and departure of important passengers and the railroad itself, the Virginia and Truckee, was a major source of employment for many Carsonites.

The most obvious reminder of those halcyon days of train travel is the yellow passenger depot still extant on the south side of East Washington Street at the corner of North Carson Street. This building, which is in the National Register of Historic Places, was built in 1872 and remained the headquarters of the V&T until the railroad folded in 1950. According to architectural historian Julie Nicoletta in her book *Buildings of Nevada* (2000), "With its board-and-batten siding and wide overhanging eaves supported by crossed diagonal brackets, the depot is a classic example of railroad architecture of the period." This Carson City landmark is now a coin shop and Masonic hall.

The Virginia and Truckee Railroad was designed to connect the mining boomtowns of the Comstock—Virginia City and Gold Hill—with Carson City and the newly created entrepôt on the Truckee River, Reno. This "Queen of the Short Lines," as it came to be called, was incorporated in 1868, largely through the efforts of three bankers: William Sharon, William C. Ralston and Darius O. Mills. They represented the Bank of

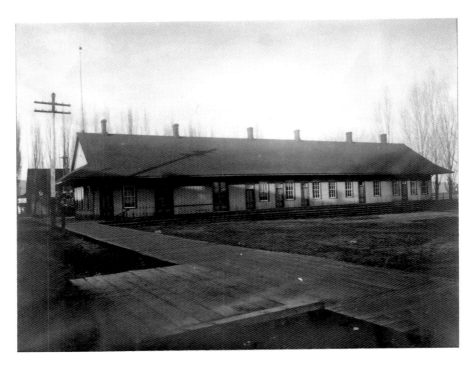

Virginia and Truckee Passenger Depot, 729 North Carson Street, built 1872. *Courtesy of the Nevada State Library and Archives.*

California's interests in the mining region and had considerable influence. The "Bank Ring," in fact, had a near monopoly on mines and mills, and to further solidify its hold on the Comstock's wealth, it sought to control transportation as well.

Hauling ore down to the mills on the Carson River and wood—mining timbers, lumber and cordwood—up from the massive wood yard in Carson City was the V&T's primary function. Passenger service, although important, was not what made the railroad profitable. To put this into perspective, Stephen E. Drew, in his book *Nevada's Virginia & Truckee Railroad* (2014), reiterated an oft-quoted statistic: "the V&T hauled enough gold and silver ore to equal the weight of all its locomotives, cars, and rails combined."

The V&T is considered an engineering marvel insofar as its twenty-one miles of track from Carson City to Virginia City conformed to the mountainous topography of the Comstock by means of tunnels, trestles and curvatures. The track was so curvy that combined it would add up to twenty complete circles while ascending or descending nearly 1,600 feet at

an average 2 percent grade. A local civil engineer, Isaac E. James, laid out the route, and in February 1869, more than one thousand Chinese workers began construction. By January 1870, the tracks reached Carson City, and two and a half years later, the V&T extended thirty-one miles north from Carson City to Reno, where it connected with the transcontinental Central Pacific Railroad. In 1906, years after Comstock ore ceased to be relevant, the V&T extended down to the Carson Valley town of Minden.

Carson City was clearly the nexus of the V&T for many reasons. The U.S. Mint, which produced coinage from Comstock gold and silver between the years 1870 and 1893, was located in the capital city. Many of the V&T staff—including superintendent Henry M. Yerington (1829–1910)—built homes in Carson City. Yerington's home, built in 1863 on the southwest corner of Division and Robinson Streets, remains one of the landmarks along the west side historic district walking tour, and his grave in the Lone Mountain Cemetery is prominent. Most importantly, however, was the fact that the V&T shops were in Carson City. Locomotives and other rolling stock needed regular maintenance, and Carson City housed a gigantic complex to meet those needs.

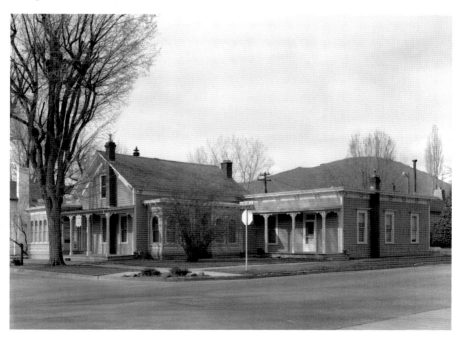

Henry M. Yerington house, 512 North Division Street, built 1863. *Courtesy of the Library of Congress.*

Those interested in the preservation of historic sites and structures realize that everything from the past cannot survive in the present and future, but hope remains that we can find a way to coexist with the most significant reminders of days gone by. Many still lament that the V&T shop complex, a Carson City landmark, was demolished in 1991. As Richard Moreno explained in *A Short History of Carson City* (2011), "[T]he iconic stone structure—often referred to as the V&T's roundhouse, despite its rectangular shape—was in poor condition." Nevertheless, several efforts were made to buy the property from the owner, who had acquired it in 1955. Various plans for adaptive reuse of the massive sandstone building were floated over the intervening years. These included turning it into Carson City government offices or having the state purchase it and include it as part of the Nevada State Railroad Museum.

Carson City residents still talk about the V&T shops and bemoan the loss. In a July 22, 2017 *Nevada Appeal* article, "Memory of V&T Roundhouse isn't fading away," writer Ronni Hannaman stated, "those who remember the historic landmark still rue the day it was demolished." She went on to explain what happened to parts of the forty-five-thousand-square-foot sandstone structure; Carson City purchased two of the eleven stone arches, which were large enough to allow passage of a locomotive (as seen in nearly every photograph of the iconic building), but most of the arches and a considerable number of sandstone blocks were shipped to wineries in the Napa Valley. She remarked, "If these stones could talk, they would say, 'Carson's loss is Napa's gain.'"

The V&T shops, though gone now, were a special place for current and former residents. This was certainly the case for Jack Curran, who was born in 1911 and spent his formative years in Carson City. He devoted an entire chapter to this extinct building in his memoir *Back to the Twenties* (1994). At the end of the chapter, he reflected on what the V&T shops meant to him:

> *When I look back a little bit at different times in my life, it surprises me just how much I learned wandering around the railroad shops as a young boy. They'd let kids go wherever they wanted to, never paying much attention to them if they behaved, and I put in all the time that I could down there watching the machines and the people. I acquired a pretty fair knowledge of many industrial-type activities, which would ordinarily have been impossible to learn in a small town.*

CORRIDORS

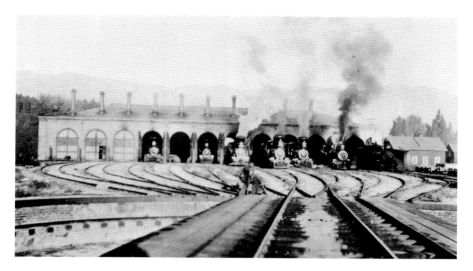

Virginia and Truckee Railroad shops, between Plaza, Ann, Stewart and Sophia Streets. *Courtesy of the Library of Congress.*

In addition to the extant passenger depot on East Washington Street and the site of the extinct V&T shops on North Stewart Street, there is one more reminder of the railroad that played such a large role in Carson City's life and livelihood. As one travels north out of Carson City and climbs the hill toward Lakeview, that low ridge that separates Eagle Valley from Washoe Valley, there are several visible scars of the V&T Railroad grade along the lower slopes of the Carson Range. They are especially evident from the vantage point of I-580 looking west beyond the roofline of the Carson-Tahoe Hospital. One can just imagine a V&T steam locomotive's funnel-shaped stack pouring out smoke as it powered up the 2 percent grade on its way up to Reno.

PONY EXPRESS AND LINCOLN HIGHWAY

Carson City and its hinterland have been traversed by many forms of travel from prehistoric times to the present. To a great degree, Mother Nature oriented these routes to the cardinal directions. The north–south trending Carson Range has tended to funnel traffic in that direction along the base of its eastern escarpment. Old Highway 395, for example, illustrates the basic pattern whereby Carsonites may travel north through Washoe Valley to the Truckee Meadows or south to the Carson Valley. The Carson River, which fundamentally flows southwest to northeast, has been a naturally determined transportation corridor. Even before the founding of Carson City, westbound migrants whose destination was the California goldfields passed through the area by following the course of the river. Also, the old Virginia and Truckee Railroad route and modern highways 395 and 50 form a T-bone shape with the Carson Range to the west. Among the various ways people have moved through the Carson City region, two may not be so well known—the Pony Express and the Lincoln Highway. Both routes conform to the underlying pattern of the place.

For something that only lasted a year and a half, the Pony Express has a large place in the lore and legend of the West. By 1860, population on the West Coast had grown exponentially thanks to the California Gold Rush. The Rush to Washoe was in full swing, and the newly laid out streets of Carson City were sprouting homes and businesses. Communication across the continent, however, remained glacially slow—the telegraph and transcontinental railroad were not completed until 1861 and 1869,

respectively. The idea of having swift riders carry the mail between St. Joseph, Missouri, and Sacramento, California, was born: a 1,966-mile route made successful by means of 157 stations where fresh horses and riders would transfer the mailbag similar to the passing of a baton in a relay race. Mail moved across half the continent in less than 10 days, an amazing feat at the time.

Mark Twain's description in his book *Roughing It* (1872) is evocative of the aura surrounding the Pony Express horse and rider:

> *The pony-rider was usually a little bit of a man, brimfull of spirit and endurance. He rode fifty miles without stopping, by daylight, moonlight, starlight, or through the blackness of darkness—just as it happened. He rode a splendid horse that was born for a racer and fed and lodged like a gentleman; kept him at his utmost speed for ten miles, and then, as he came crashing up to the station where stood two men holding fast a fresh, impatient steed, the transfer of rider and mail-bag was made in the twinkling of an eye, and away flew the eager pair and were out of sight before the spectator could get hardly the ghost of a look.*

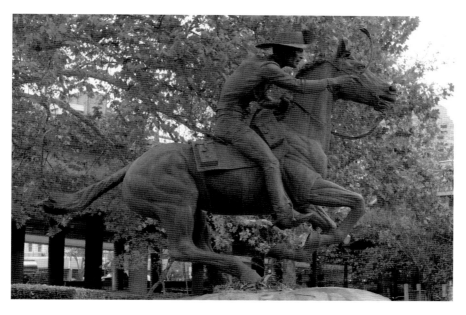

Statue of a Pony Express horse and rider by sculptor Thomas Holland in Old Sacramento, the eastern terminus of the route, which passed through Carson City. Photograph by Carol M. Highsmith, 2012. *Courtesy of the Library of Congress.*

Pony Express marker, West Third Street pedestrian mall. *Photograph by the author.*

Carson City became a designated station along the Pony Express. The building no longer exists, but it was situated somewhere on Carson Street between Third and Fifth Streets. In fact, the town served the Pony Express as a division headquarters as well as a station, where the agent, one Bolivar Roberts, oversaw the operation. A monument on the grounds of the U.S. Mint commemorating the Pony Express through Carson City was dedicated on July 20, 1960, the centennial year of this brief but iconic route. Another monument, located on the Third Street pedestrian mall, was dedicated on April 12, 1996. It is an impressive polished granite slab showing the east–west Pony Express route across Nevada with each station identified, as well as an etched depiction of horse and rider galloping across the landscape.

Years later, another form of travel entered the scene: the automobile. Although Reno is a major hub along a transcontinental transportation corridor that today includes Amtrak's California Zephyr route and Interstate 80, Carson City was not ignored when America's first coast-to-coast highway was conceived. Beginning in 1912, the Lincoln Highway Association (LHA) envisioned a hard-surface road extending more than three thousand miles from New York's Times Square to San Francisco's Golden Gate. Named for President Abraham Lincoln, the route covering thirteen states gained in popularity as Americans wholeheartedly embraced the automobile.

Most drivers traveling across northern Nevada today take I-80, but a parallel road to the south, Highway 50, is, for much of its path, the old Lincoln Highway. Before that, it was the route of the Pony Express. Highway signs along this stretch of US 50 between Fallon and Ely proclaim it "The Loneliest Road in America," a moniker derived from a July 1986 *Life* magazine article. A little west of Fallon, the Lincoln Highway split into two routes, one going up to Fernley, Reno, and over Donner Pass, the other to Carson City, Lake Tahoe and over Echo Summit. The more southerly alternative, which some considered the more scenic, was called the Pioneer

Left: Lincoln Highway monument on the grounds of the Nevada State Museum, northwest corner of West Robinson and North Carson Streets. *Photograph by the author.*

Below: Portion of Lincoln Highway–Kings Canyon Road. *Courtesy of the Library of Congress.*

Branch. The two routes, roughly synonymous with old US 40 and US 50, joined in Sacramento and continue as a single highway the rest of the way to San Francisco.

The Lincoln Highway through Carson City formed a dog-leg—eastbound out East William Street, westbound out West King Street—and in between, it ran along Carson Street. The LHA published a series of guides, and reading them offers a glimpse into the past, a sense of what it would have been like to travel the Lincoln Highway at the time. The 1924 *Road Guide*, for example, has in its Carson City section advertisements for two businesses: the Arlington Hotel and the Red Arrow Garage. (Apparently, not much has changed, as travelers still want to know where to stay and where to get gas.) The proprietor of the Arlington Hotel, W.J. Maxwell, also served as a local official of the LHA—doubtless a position good for business and justification for the two dollars per night he charged.

The 1924 *Road Guide* has a brief description for significant stops along the way, and the one for Carson City provided a succinct portrait: "Pop. 1,685. Alt. 4,675 feet. County seat, Ormsby County and Capitol [*sic*] of the State of Nevada. Four hotels, 3 garages. Local speed limit 15 miles per hour. One bank, V. & T. Railroad, 85 general business places, express company, telegraph, 2 newspapers." The *Road Guide* can also get a little boosterish, bordering on the hyperbolic: "It has been said, and truly, that the country for miles around Carson City is a scenic wonderland. Nowhere else can such wonderful wooded mountains and hills be found. No other mountain highway reveals such vast and glorious panoramas. No other valley road affords such views of mountains, sharply outlined against azure and purple skies." That is language worthy of a chamber of commerce or office of tourism.

There are few remnants of the Lincoln Highway in and near Carson City, but one is the route up to Lake Tahoe via the Kings Canyon Road, which also went by the name of the Ostermann Grade for a time in honor of a LHA official. Today, this route eventually meets up with modern US 50 at Spooner Summit, but its rocky and rutted grade is best left to hikers, mountain bikers and vehicles capable of handling that type of terrain. In town, the Arlington Hotel and the Red Arrow Garage are long gone, but there is a concrete post bearing the Lincoln Highway logo on the grounds of the old U.S. Mint on North Carson Street. In 1927, the LHA ceased to operate, deferring to the U.S. Bureau of Public Roads. As a final act, the LHA provided three thousand concrete markers to be simultaneously placed on September 1, 1928, by Boy Scout troops across the country. Carson City has one.

THE STREETS OF CARSON

In many respects, Nevada's capital city may be thought of as the center of a compass, aligned as the gridded streets are to the major compass points. This rectilinear town grid pattern is actually the norm for towns and cities beyond the colonial Eastern Seaboard, and as such, it is often taken for granted that communities are laid out in such a fashion. Geographers, urban planners, surveyors and others recognize that a town grid is merely a reflection of our national obsession with the cardinal directions. It is a microcosm of the greater grids that cover the country (the township and range system) and the world (latitude and longitude).

If asked to identify the center of Carson City, most people—residents and visitors alike—would naturally zero in on the center of the compass, or central business district (CBD). This is a geography we intuitively understand; it is the hub of any town or city and often where street names change direction—north to south and east to west. In Carson City, that nexus is the former junction of Carson and King Streets—former because the old Kings Canyon Road no longer reached Carson Street after the block between Carson and Curry Streets was closed off and the old supreme court building constructed. And, of course, opposite the point where West King Street used to intersect Carson Street is the plaza where the Nevada State Capitol is situated. (There is an East King Street on the other side of the plaza; it continues east of Stewart Street.) As a consequence, all streets west of Carson Street are designated west, and all streets east of Carson Street are designated east. King Street does the same for north and south designations.

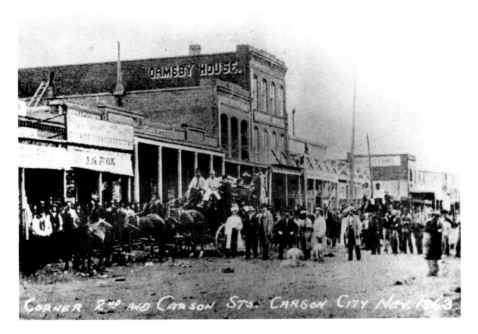

Street scene in front of the Ormsby House, southwest corner of West Second and South Carson Streets, 1863. *Courtesy of the Nevada State Library and Archives.*

For example, facing Curry Street but on opposite sides of King Street, the Rinckel Mansion's address is 102 North Curry Street, whereas the Edward D. Sweeney Building's address is 102 South Curry Street.

Carson City's grid layout is unremarkable in another respect; it conforms to a model often referred to as the "Courthouse Square." The hallmark of this town plan, as the name suggests, is a plaza occupied by a large governmental building in the middle of town. In most cases, these towns are county seats, and the central square is dominated by a county courthouse. The courthouse usually faces the most important, or main, street, and the streets on the other three sides of the plaza are most commonly considered the CBD because of a preponderance of commercial buildings. To reiterate what geographer Richard V. Francaviglia argued in his book *Main Street Revisited* (1996), this town plan is not strictly an American invention but has obvious European antecedents. A visit to the plaza in Sonoma, California, for example, will verify that the Hispanic plaza predates the American county courthouse. Carson City's center, which is dominated by the state capitol on a plaza set aside by Abraham Curry, should be viewed as conforming to a much larger European-American cultural pattern.

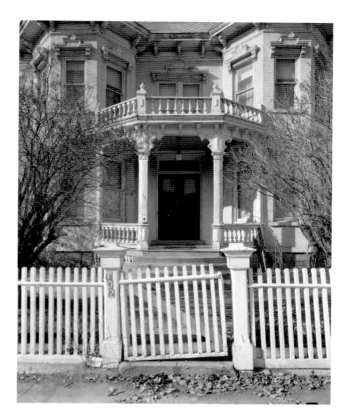

Right: Mathias Rinckel Mansion, 102 North Curry Street, built 1875–76. *Courtesy of the Library of Congress.*

Below: Edward D. Sweeney Building, 102 South Curry Street, built 1864. *Courtesy of the Library of Congress.*

Probably more interesting than a discussion of street patterns or town plans is how certain streets got their names. This often falls under the rubric of place names or, to use the technical term, toponyms. Entire books are devoted to the subject of place names. For example, Helen S. Carlson's *Nevada Place Names: A Geographical Dictionary* (1974) is the standard reference book for the state of Nevada. Additionally, several monographs on the place names pertaining to Carson City are in print, including two by Mary B. Ansari: *Carson City Place Names* (1995) and *Nevada Heartland: The Place Names of Carson City, Douglas, Lyon and Storey Counties, Nevada* (2015). Thumbing through these references reveals that some names are more interesting than others, but all have a story to tell.

The following is a brief explanation of selected street names in Carson City. It is by no means comprehensive but instead is meant to convey how history can be etched on something as simple as a street sign. Many of the street names in the historic core of town are people's names. Not surprisingly, Carson City's founding fathers—Curry, Proctor and Musser, among others—have streets named for them. (Curry Street was formerly Ormsby Street.) The derivation of the main street itself, Carson Street, is obvious; explorer Christopher "Kit" Carson's name is seemingly everywhere in the area—as a pass, river, valley, mountain range, street and, of course, state capital. Some names on Carson City's street signs have been all but forgotten. They may have been individuals who did not figure prominently in the historical record or may represent some aspect of the community that is no longer apparent. Most of the street names discussed here are within, or near, the downtown and west side walking tour known as the Kit Carson Trail.

The least creative street names in Carson City are the sequentially numbered streets south of West King Street: Second, Third, Fourth and Fifth. Note there is no First. It is understood that King Street would be first in the sequence were it so named. This substitution only serves to underscore the importance of the historic Kings Canyon Road as an early and major thoroughfare.

A number of streets are named for women—Ann, Caroline, Elizabeth and Sophia—who were, as one would expect, early settlers of Carson City when the town was expanding in the early 1860s. Elizabeth Street, for example, was named for Elizabeth M. Phillips. Elizabeth and her husband, Henry S. Phillips, along with their four sons, were among the earliest settlers, having arrived in Carson City in late 1859. According to former Nevada state archivist Guy Rocha, they "bought up large tracts of land [and] laid

CORRIDORS

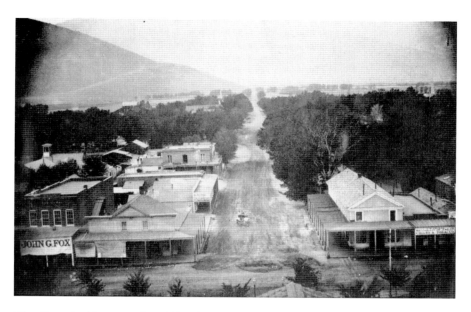

King Street looking west, circa 1880. *Courtesy of the Library of Congress.*

out the Phillips Addition in the territorial capital's northwest town limits. Among the streets named in the subdivision were Phillips, Elizabeth, and Mountain streets."

The aforementioned King Street was named for Dr. Benjamin L. King, who truly was an Eagle Valley pioneer. In 1852, well before Abraham Curry and others arrived on the scene and envisioned a town, King found a valley at the base of the Carson Range to his liking and settled there. Dr. King's ranch now bears the name Kings Canyon, and the road from there due east becomes King Street as it enters town. One can appreciate its importance from a landscape perspective by driving out Kings Canyon Road up a slight alluvial fan of the Carson Range and turning around. From this vantage point, the road goes straight as an arrow to the capitol building's silver dome.

Two streets that run parallel to, and east of, the all-important Carson Street are Stewart Street and Roop Street. Stewart Street is named for William M. Stewart (1827–1909), a native of New York State who was lured west by the California Gold Rush in 1850. He later studied law, rose to prominence as an attorney on the Comstock and was said to have made a small fortune from all the mining litigation. He is best remembered, however, as having served as a U.S. senator from Nevada for twenty-eight years. Roop Street is named for Isaac N. Roop (1822–1869), who immigrated to northern

California in 1851, eventually settling on the east side of the Sierra in what is now Susanville (named for his daughter Susan). By 1859, many residents on the east side of the Sierra in what was Utah Territory were clamoring for political autonomy and proposed a provisional territorial government. Susanville was thought to be part of Nevada at the time, and Isaac Roop was elected governor of the proposed territory of Nevada by an ad hoc assembly. When Congress finally approved the creation of Nevada Territory in 1861, Roop served in the new Territorial (and later State) Senate in Carson City until 1865, at which time he returned to Susanville, California.

Several streets bear names that should be self-evident. These include Telegraph Street, Plaza Street and Hot Springs Road. Telegraph Street is so named because Carson City was the headquarters of the Carson and Tahoe Lumber and Fluming Company and home of its superintendent Duane L. Bliss. Bliss wanted to maintain communications with his lumber operations at Glenbrook on the east shore of Lake Tahoe, so he had a telegraph line installed, and its route in town followed Telegraph Street. Plaza Street, as the name suggests, is a short street one block east of Carson Street and immediately north of the capitol plaza. Hot Springs Road is one of the few streets not conforming to a cardinal direction orientation. It runs northeast-southwest between the north end of town and the Carson Hot Springs (not to be confused with Curry's Warm Springs next to the Nevada State Prison). In all likelihood, Hot Springs Road was a trail used by Native Americans for many years.

It goes without saying that Carson City has many more streets, most of which have stories behind their names or why the street is where it is or has a particular configuration. The Carson City Chamber of Commerce advocates a sightseeing tour of town and suggests the best way to savor the ambience of Nevada's capital city is on foot. Walk the streets, especially those of the capitol complex, the CBD and the west side historic district. Consider the advice of geographer Carl O. Sauer: "Locomotion should be slow, the slower the better; and should be often interrupted by leisurely halts to sit on vantage points and stop at question marks."

PART VII
CARSON CITY CONTINUES

THE CITY-COUNTY

On July 1, 1969, Carson City and Ormsby County merged into a single governmental unit. Ormsby County was effectively dissolved, making Carson City independent of any county government. The official name is the Consolidated Municipality of Carson City. This is a political arrangement not unique in the United States—San Francisco, for example, is a consolidated city-county. No other cities in Nevada, however, have shed their county affiliation.

Carson City's justification for doing so was twofold: there were no other communities in the county, and Ormsby County, at only 156 square miles, was small by Nevada standards. It made no sense to maintain two layers of government. In *A Short History of Carson City* (2011), Richard Moreno cited an almost humorous example of how dysfunctional the dual governments could be before consolidation: "[One] time the Carson City Police Department and the Ormsby County Sheriff's Department began to publicly squabble during a city council meeting because a city police car had crossed into the county."

One interesting consequence of this governmental merger is that Carson City's political boundaries extend up to the middle of Lake Tahoe. Lake Tahoe, the gem of the Sierra, has been, and remains, a curiously divided place, as author Michael J. Makley explains in his book *Saving Lake Tahoe* (2014): this beautiful alpine lake is bisected by the states of California and Nevada "sharing jurisdiction with five counties." Two of those counties are in California—El Dorado and Placer—and three in Nevada—Washoe,

Lost Carson City

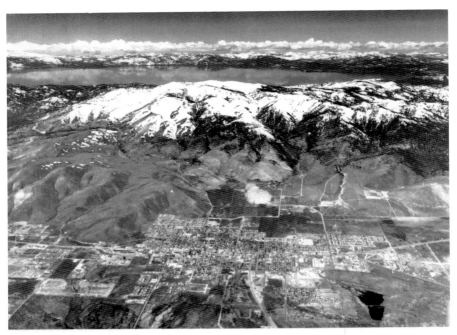

Aerial view looking west from over Carson City to Lake Tahoe. *Courtesy of the Nevada State Library and Archives.*

Douglas and the Consolidated Municipality of Carson City, also informally known as Carson City County.

Taking a wider view of Carson City, therefore, requires looking beyond former city limits, especially in a westerly direction. Most of the mountainous land between Eagle Valley and the east shore of Lake Tahoe is under federal—U.S. Forest Service—administration. The east side of the Carson Range is part of the Carson Ranger District of the Humboldt-Toiyabe National Forest, and the west side is administered by the Lake Tahoe Basin Management Unit. There are some privately owned parcels in the mountains and along the Lake Tahoe shoreline, but by and large, this forested expanse is federal land. This is not surprising, as 85 percent of the land in the state of Nevada is owned by the federal government.

The forests between Eagle Valley and Lake Tahoe have undergone a dramatic landscape change, as mentioned in an earlier chapter of this book. The standing timber was practically clear-cut during the boom years

of the Comstock Lode. After Duane L. Bliss's Carson and Tahoe Lumber and Fluming Company cut the old-growth forest, leaving a landscape of stumps, the land was considered to be of little value. In 1936, the wealthy and eccentric George Whittell Jr. (1881–1969) bought up forty-five thousand acres, including more than twenty miles of Lake Tahoe shoreline. After his passing, the State of Nevada and the federal government acquired most of the Whittell property. This explains why there is so little development on Lake Tahoe's east shore, including that portion within the Consolidated Municipality of Carson City.

THE CHANGING LANDSCAPE

Robert Laxalt's novel *The Basque Hotel* (1989) concludes with a reflection on change. In this beautiful coming-of-age story set in Nevada's state capital, the narrative reveals protagonist Pete's thoughts: "Carson City was changing. Everything was changing. And he wondered if he had begun to change, too." The style of the novel is very much like that of another former Carson City resident. *The Adventures of Tom Sawyer* (1876), by Mark Twain, is about a rambunctious boy and his town and its environs. Both stories are thinly veiled autobiographies in which the setting—Carson City, Nevada, and Hannibal, Missouri—almost becomes a real flesh-and-blood character. We develop an intimate relationship with places, most especially the hometowns of our childhood.

Small towns like Carson City and Hannibal, Missouri, are near and dear to the collective American psyche, despite the fact that four-fifths of us are now urban-dwellers. They represent all that is good, clean and decent, and even though small towns are not free from society's ills, this romantic vision persists. Perhaps that is why Walt Disney selected a small-town "Main Street USA" as the portal to Disneyland, that southern California icon, which opened in 1955.

Carson City, despite being the state capital, was, for most of its history, a small town. At the turn of the twentieth century, Carson City's population was 2,893. During the Big Bonanza up on the Comstock, Carson City benefited from the mining boom, but even still, the 1880 population of the state capital was only 5,412. By comparison, San Francisco, a genuine

Carson City Continues

metropolis, had a population of 233,959 in 1880, and California's state capital, Sacramento, had 21,420 residents, nearly four times that of its counterpart capital in the Silver State. Even as recently as 1970, Carson City's population was only 15,468.

Carson City retains a small-town feel, even though the current (as of 2017) population is in excess of fifty thousand. When compared to the Reno-Sparks metropolitan area half an hour's drive north on Interstate 580, which has something approaching half a million residents, Carsonites appreciate the smallness of their hometown. The place has many amenities—a hospital, a college, a nice public library and lots of shopping, dining and entertainment options—without any of the headaches of the big city. There is no rush hour in Carson City—no gridlock at traffic lights—and one can usually find a parking place downtown with little or no difficulty. The only exception to that is during the Nevada Day Parade.

That is not to say that Carson City is a small town frozen in time. Robert Laxalt's character, the young Pete, was correct in sensing change in the late 1920s and early 1930s. There have been significant changes in Nevada's capital city, as there have been changes across the country—and usually for the same reasons. The following are examples of how Carson City has changed, particularly with respect to the cultural landscape.

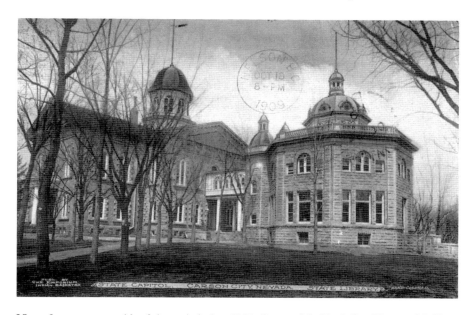

View of annex on east side of the capitol, circa 1905. *Courtesy of the Nevada State Library and Archives.*

In her recent book *The Nevada State Orphans/Children's Home: My Life as a "Home" Kid* (2016), author Bonnie Boice Nishikawa described, in a very personal way, what life was like in a Carson City institution that no longer exists. In fact, orphanages as a social institution are a thing of the past, having been replaced, in this country anyway, by foster homes and adoption services.

The Nevada State Orphans Home was created by the state legislature in 1869. It replaced the Nevada Orphans Asylum begun in Virginia City in 1864 by the Comstock's beloved Catholic priest, Farther Patrick Manogue, and Sister Frederica McGrath of the Sisters of Charity. In 1870, a two-story wood-frame Victorian home was constructed on a seventeen-acre site on what was, at the time, the eastern margin of town. The parcel, on the southeast corner of East Fifth and Stewart Streets, had been purchased by a group of citizens, Abraham Curry among them, and subsequently donated to the State of Nevada.

The wooden home burned in 1902, and its replacement, a much more substantial and solid edifice built of state prison–quarried sandstone, was completed in 1903. Sixty years later, the second Nevada State Orphans Home had outlived its usefulness and was demolished to make room for a different living arrangement. Smaller cottages, less institutional in appearance and in practice, replaced the big dormitory. The complex of cottages closed in 1989 when a system of foster care in private homes became the norm.

Bonnie Boice Nishikawa's experience growing up in the Nevada State Orphans Home from 1942 to 1955 was, like the recollections of most

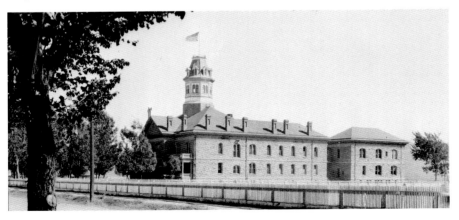

Second Nevada State Orphan's Home, circa 1903. East Fifth and Stewart Streets. *Courtesy of the Library of Congress.*

children, a kaleidoscope of emotions. Her telling of this chapter of her life is sad, heartwarming and even funny. Looking back on those years, these are her conclusions:

> *Since 1870, the Children's Home was home to 3,300 children, some only staying for a short time, others for most of their childhood. As a Home Kid myself, I can honestly say that the Children's Home gave us a solid foundation, a set of values and a sense of family. It enabled children to form strong ties that lasted a lifetime.*

Interestingly, in Robert Laxalt's novel *The Basque Hotel*, Pete's best friend Tony lived at the Orphans Home. As Bonnie Boice Nishikawa explained, children were (and will be) children; they did not live in institutional isolation but were instead full-fledged members of the Carson City community.

Another institution that no longer exists in Carson City is the poor farm. Before the days of federal public assistance programs—welfare, subsidized housing, food stamps and so forth—counties and municipalities across the country took responsibility for the less fortunate. Ormsby County (which became a merged Carson City and County in 1969) had its own poor farm, as Richard Moreno noted in *A Short History of Carson City* (2011):

> *In the 1860s, the Ormsby County Poor Farm had been established at the south edge of Eagle Valley on Old Clear Creek Road for those unable to find work and an affordable place to live. Less-fortunate citizens could live in a dormitory-like building erected on the banks of Clear Creek and work on the farm, earning a few dollars.*

The poor farm property on Clear Creek became Fuji Park, thanks to a generous gift to the county by author and playwright Basil D. Woon (1893–1974). Fuji was his wife's name, and Woon wanted to honor her memory with a public park. Perhaps not coincidentally, this generous man wrote a piece for the *Nevada State Journal*, published on December 28, 1952, titled "Christmas Day at Sunny Acres a Success, and All Nevada May Well Be Proud." It is quoted in its entirety in Bonne Boice Nishikawa's book, but suffice it to say, it relates his having been a guest for Christmas dinner at "Sunny Acres," the children's new name for the Nevada State Orphans Home. In the piece, he referenced Charles Dickens, which conjures up a host of images and provides a powerful subtext.

The Nevada State Prison (NSP) provides another example of Carson City's changing landscape. This institution east of town has been part and parcel of Carson City since territorial times. The beginnings of the prison can be traced directly to Abraham Curry's Warm Springs Hotel. The territorial legislature realized early on that a prison was an unfortunate necessity, but there was no budget to build one. Curry stepped up and offered to house prisoners in his hotel, which, in essence, made him the first warden. Eventually, the territorial government had sufficient funds to buy the property—the hotel, sandstone quarry and more than twenty acres—for $80,000.

The importance of the prison sandstone quarry as a source of building material for Carson City has been mentioned multiple times throughout this work. So many buildings—civic, residential, commercial and ecclesiastical—were built with these durable blocks, one could argue the imprint of the Nevada State Prison is not confined to Curry's Warm Springs parcel; it is all over town.

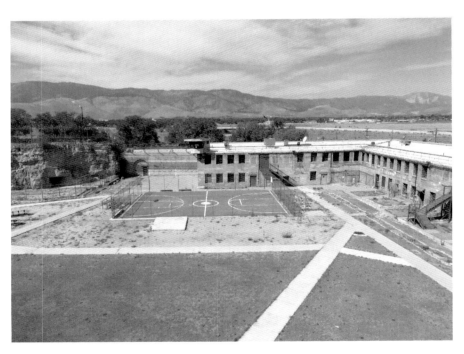

Nevada State Prison, looking northwest. Photograph by Dan Pezzoni. *Courtesy of the Nevada State Historic Preservation Office.*

The Nevada State Prison housed the most dangerous and violent offenders, as well as others who perhaps could be considered petty criminals. Following a 1901 law passed by the state legislature, the Nevada State Prison was the only location in the state where a death sentence could be carried out. In fact, in 1924, it became the first prison in the country where a gas chamber was used as a form of execution.

For prisoners not in solitary confinement or contemplating their imminent demise, incarceration at the Nevada State Prison could actually have moments of fun and diversion. In their book *Nevada State Prison* (2012), authors Jennifer E. Riddle, Sena M. Loyd, Stacy L. Branham and Curt Thomas described how prison administrators allowed inmates to enjoy themselves Nevada-style:

> *After a hard day working, relaxing with a bit of prison-sanctioned entertainment must have been a treat. In a move that one sees as being uniquely Nevada-like in nature, NSP had a legal, prison-operated casino within its boundaries. Beginning in 1932, prisoners could gamble on card games and dominos. Inmates made poker chips out of discarded records, and some talented individuals hand-painted cards with which to play. The prison even had its own currency known as "prison brass." Eventually, the casino expanded to include table games and sports betting. In addition to gambling, the prison had baseball teams, basketball teams, and boxing teams. There was even a prison band called The Boys in Blue, which performed at charitable events and was featured on a weekly radio program.*

The Nevada State Prison in Carson City is not the only prison in the state. Newer prisons are scattered across the state and include the Ely State Prison (opened 1989) in White Pine County, the High Desert State Prison (opened 2000) in Clark County, the Lovelock Correctional Center (opened 1995) in Pershing County and the Florence McClure Women's Correctional Center (opened 1997) in Clark County, among others. In 2011, the Nevada Department of Corrections recommended the Nevada State Prison in Carson City be closed and inmates moved to other, more modern, correctional facilities. After all, the Carson City prison was older than the state itself, and as the authors of *Nevada State Prison* pointed out, "[The NSP] was more expensive to operate than other facilities and…the prison needed structural upgrades that were too costly to justify."

The Nevada State Prison, which had operated since 1862, officially closed on May 12, 2012. There is some talk of transforming the old prison into a

museum and tourist attraction, largely due to a group calling itself the Nevada State Prison Preservation Society, and it is more than just something on the drawing board. In 2015, Governor Brian Sandoval signed a bill (Assembly Bill 377) that "Establishes provisions for the preservation, development and use of the Nevada State Prison as a historical, cultural, educational and scientific resource." What eventually becomes of the old prison has yet to be determined. Since its closure, however, the National Park Service has included the Nevada State Prison in the National Register of Historic Places, a designation acknowledging its historical and architectural significance.

There are other changes afoot in Carson City not necessarily involving historic buildings. Since its nineteenth-century beginnings, Carson City has been a small town whose immediate hinterland is agricultural. Several ranches still exist within city limits. Carson City may even be called a cowtown insofar as there are cattle grazing just blocks from the Governor's Mansion. Sheep also graze seasonally on the lower slopes of the Carson Range immediately west of town. A drive along the newly completed Interstate 580 cuts through ranch land, affording a unique view of the capital city—cattle and the Lompa Ranch's century-old barn in the foreground with the dome of the capitol visible above the trees in the middle distance.

The Lompa Ranch, with the ranch house and outbuildings centered on East Fifth Street between the edge of town and the Nevada State Prison, is described by Richard Moreno as "the largest parcel of undeveloped private land remaining in Carson City." The Lompa family acquired the 820-acre property from a Swiss-Italian immigrant, Steve Belli, in 1936. Initially, they had dairy cows and sheep but, in the 1960s, switched to cattle ranching.

As is often the case involving agricultural land adjacent to urban areas, the Lompa Ranch has been shrinking in size to accommodate development. First, in the early 1970s, the family donated a substantial parcel for the site of Carson High School. More recently, they sold eighty-two acres to the state to allow construction of Interstate 580. As of this writing (December 2017), Ryder Homes has purchased sixty-two acres of Lompa Ranch land, and the city has approved its master plan to construct 189 single-family homes and 350 apartments. Construction is slated to begin the first quarter of 2018.

Other ranches in Eagle Valley have felt the pressure of development. The Gardner Ranch extended over a large portion of Carson City south of the intersection of South Carson and Stewart Streets. The ranch house was located approximately where the U.S. Forest Service office is now. According to Nevada State Historical Marker No. 194, "On this site in the period from 1870 until 1918 stood the ornate, two-story home of Matthew Culbertson

Carson City Continues

Lompa Ranch, East Fifth Street. *Photograph by the author.*

Gardner, rancher and lumberman. The residence was headquarters for Gardner's 300 acre ranch in meadows to the southward." Another ranch, the Nevers-Winters Ranch, consisted of several hundred acres on the west side of town near Ash Canyon. It was settled in the 1850s, and the city began to slowly encroach, but not completely. The Raycraft Ranch, once a three-hundred-plus-acre parcel at the north end of Carson City, had the distinction of facilitating the first airplane flight in Nevada when a plane took off from the ranch on June 23, 1910.

The Borda family, with headquarters in Carson Valley, has been grazing sheep in the region for more than a century. They continue the tradition of Basque sheepherding that has been such an important part of Nevada's cultural heritage for so long, one that Robert Laxalt wrote so eloquently about in his book *Sweet Promised Land* (1957). Pickup trucks with the name "Borda Land and Sheep" emblazoned on the side can be seen in the vicinity of Kings Canyon in Carson City every spring, as they graze more than two thousand animals on the hillsides. Local, state and federal agencies happily grant grazing permits to the Bordas because the sheep and lambs actually help reduce wildfire hazards by cropping the vegetation on these lands.

St. Peter's Episcopal Church, 314 North Division Street, built 1868. *Courtesy Library of Congress.*

Carson City, it seems, is in transition. There is still enough of "Old Carson" in and around town so that residents and visitors alike can readily experience a landscape imbued with historical ambiance. The cynic might argue that Carson City is not what it used to be, but that can be said

Carson City Continues

of most places to one degree or another. Someone waxing nostalgic may even cite a refrain from Joni Mitchell's environmental anthem "Big Yellow Taxi": "They paved paradise and put up a parking lot." Yes, there are parking lots in Carson City, and there are buildings and landscapes that are gone, but all things considered, Nevada's capital city would still be recognizable to those who lived here years ago.

EPILOGUE

One may argue that to spend any time in Carson City and not gain some appreciation for its history is next to impossible. While shopping at Morley's Books on the corner of West King and South Curry Streets, for example, there is a keen awareness of being in a historic building—the E.D. Sweeney Building, built in 1864—and the thought "if these walls could talk" may well come to mind. The owner of the store and the building, Michael Morley, is always happy to offer up historical tidbits while his customers search for a copy of *Roughing It* or *The Basque Hotel*.

Carson City is growing, of course, and sometimes, the new and the old are in conflict. Fortunately, there are a number of groups and organizations that believe the historic built environment is a legacy that enriches our daily lives, and it is something worthy to pass on to future generations. Carson City has a Historic Resources Commission (HRC), for example, a seven-member group appointed by the Board of Supervisors. Although the HRC is mainly concerned with developments within the west side historic district, it shares an ethos that we can live in layered landscapes where not everything old is bulldozed to make way for the modern. The Nevada State Historic Preservation Office, a state agency, also has considerable say over what happens to historic properties in and around Carson City.

There are losses. Carson City residents still mourn the destruction of the old V&T Railroad shops, just like Reno residents still wonder why the old Mapes Hotel could not have been saved. At the national level, a dialogue has been ongoing for some time, as exemplified by books such as

Epilogue

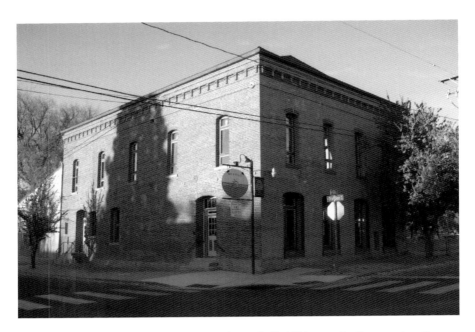

Carson Brewing Company, 449 West King Street, built 1864, now the Brewery Arts Center. *Photograph by the author.*

Preserving Cultural Landscapes in America (2000). To some, preservationists are shrill luddites represented in caricature by the woman in the 1985 hit movie *Back to the Future* who hands out "SAVE THE CLOCK TOWER" flyers to all passersby. To others, however, preservationists are people who have a passion for the past; they are convinced we need the past around to remind us of who we are. Perhaps that is why the National Archives in Washington, D.C., has the inscription "What Is Past Is Prologue" on the front of its Neoclassical building.

What is lost, either physically or in some historical detail, is the raison d'être of The History Press's Lost Series. This book contributes to that series insofar as it focuses attention on some less well known and underappreciated aspects of Carson City's history. The author of this book recognizes that in an ideal world we should adaptively reuse our cherished historic resources; the U.S. Mint in Carson City becoming the Nevada State Museum serves as an excellent example. On the other hand, there is a nostalgic respect for the past when we put it aside and move forward, which explains the manual typewriter, honored but idle, in the author's study. It had its time and its place.

Epilogue

A Carson City Landmark, the St. Charles Hotel today. *Photograph by the author.*

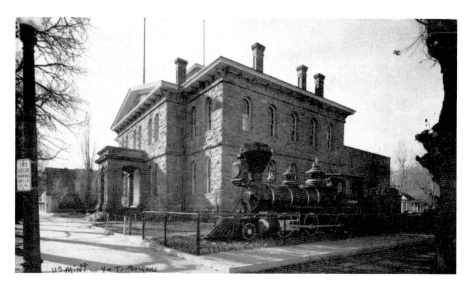

Old U.S. Mint (Nevada State Museum) with the V&T locomotive Glenbrook. *Courtesy of the Nevada State Library and Archives.*

Epilogue

What was lost may be found, and I hope this book has accomplished that with respect to some of the lesser-known aspects of Carson City's cultural landscape. Although Carsonites revel in the history and culture of their little city beneath the Sierra, and the town is bristling with historical markers, many stories about the place and its people need to be told in greater detail.

RESOURCES

For those interested in additional information about historic Carson City—lost or otherwise—the following list should prove useful.

Carson City Chamber of Commerce
1900 South Carson Street
Carson City, NV 89701
(775) 882-1565

Carson City Ghost Walk
C/O Brüka Theatre
99 North Virginia Street
Reno, NV 89501
(775) 348-6279

Carson City Historical Society
1207 North Carson Street
Carson City, NV 89701
(775) 883-4154

Carson City Visitors Bureau
716 North Carson Street
Carson City, NV 89701
(775) 687-7410

Resources

Nevada Day Parade
716 North Carson Street
Carson City, NV 89701
(775) 882-2600

Nevada Legislative Gift Shop (and Publications)
401 South Carson Street
Carson City, NV 89701
(775) 684-6835

Nevada State Museum (old U.S. Mint)
600 North Carson Street
Carson City, NV 89701
(775) 687-4810

Nevada State Railroad Museum
2180 South Carson Street
Carson City, NV 89701
(775) 687-6953

Nevada Tourism Commission
401 North Carson Street
Carson City, NV 89701
(775) 687-4322

Stewart Indian School/Nevada Indian Commission
5500 Snyder Avenue
Carson City, NV 89701
(775) 687-8333

SELECTED BIBLIOGRAPHY

Alanen, Arnold R., and Robert Z. Melnick, eds. *Preserving Cultural Landscapes in America*. Baltimore, MD: Johns Hopkins University Press, 2000.

Angel, Myron, ed. *History of Nevada*. Oakland, CA: Thompson and West Publishing, 1881.

Ansari, Mary B. *Carson City Place Names: The Names of Old Ormsby County, Nevada*. Reno, NV: Camp Nevada, 1995.

———. *Nevada Heartland: The Place Names of Carson City, Douglas, Lyon and Storey Counties, Nevada*. Reno, NV: LeRue Press, 2015.

Ballew, Susan J., and L. Trent Dolan. *Early Carson City*. Charleston, SC: Arcadia Publishing, 2010.

Carlson, Helen. *Nevada Place Names*. Reno: University of Nevada Press, 1974.

Carson City Preservation Coalition. *The Charles W. Friend Trail: An "East Side" Historical Driving Tour of Carson City, Nevada*. Privately printed booklet, 1999.

Cerveri, Doris. *With Curry's Compliments: The Story of Abraham Curry, Founder of Nevada's Capital City and Father of the Carson City Mint*. Elko, NV: Nostalgia Press, 1990.

Chambers, S. Allen Jr., ed. *The Architecture of Carson City, Nevada: Selections from the Historic American Buildings Survey Number 14*. Washington, D.C.: National Park Service, 1972.

Chung, Sue Fawn, with the Nevada State Museum. *The Chinese in Nevada*. Charleston, SC: Arcadia Publishing, 2011.

Clark, Walter Van Tilburg, ed. *The Journals of Alfred Doten, 1849–1903*. Reno: University of Nevada Press, 1973.

Selected Bibliography

Conaway, James. *Vanishing America: In Pursuit of Our Elusive Landscapes*. Berkeley, CA: Counterpoint Press, 2008.

Consolidated Municipality of Carson City, Nevada. *The Kit Carson Trail: A Tour of Historical Carson City*. Privately printed map, 1992.

Curran, Jack. *Back to the Twenties: His Memories of Growing Up in Carson City*. Virginia City, NV: Above and Beyond Publishers, 1994.

Dan De Quille [William Wright]. *History of the Big Bonanza*. Hartford, CT: American Publishing Company, 1876.

Dangberg, Grace. *Carson Valley: Historical Sketches of Nevada's First Settlement*. Gardnerville, NV: Carson Valley Historical Society, 1972.

DeCourten, Frank, and Norma Biggar. *Roadside Geology of Nevada*. Missoula, MT: Mountain Press Publishing Company, 2017.

Downs, James F. *The Two Worlds of the Washo: An Indian Tribe of California and Nevada*. New York: Holt, Rinehart and Winston, 1966.

Drew, Stephen E. *Nevada's Virginia & Truckee Railroad*. Charleston, SC: Arcadia Publishing, 2014.

Earl, Phillip I. *This Was Nevada*. Reno: Nevada Historical Society, 1986.

Fiero, Bill. *Geology of the Great Basin*. Reno: University of Nevada Press, 1986.

Francaviglia, Richard V. *Main Street Revisited: Time, Space, and Image Building in Small-Town America*. Iowa City: University of Iowa Press, 1996.

Goe, Rusty. *The Mint on Carson Street: A Tribute to the Carson City Mint & a Guide to a Complete Set of "CC" Coins*. Reno, NV: Southgate Coins and Collectibles, 2003.

Green, Michael S. *Nevada: A History of the Silver State*. Reno: University of Nevada Press, 2015.

Harpster, Jack. *100 Years in the Nevada Governor's Mansion*. Las Vegas, NV: Stephens Press, 2009.

Hickson, Howard. *Mint Mark "CC": The Story of the United States Mint at Carson City, Nevada*. Carson City: Nevada State Museum Popular Series No. 4, 1972.

James, Ronald M. *The Roar and the Silence: A History of Virginia City and the Comstock Lode*. Reno: University of Nevada Press, 1998.

———. *Temples of Justice: County Courthouses of Nevada*. Reno: University of Nevada Press, 1994.

James, Ronald M., and Elizabeth Safford Harvey. *Nevada's Historic Buildings: A Cultural Legacy*. Reno: University of Nevada Press, 2009.

Jones, Janet. *Haunted Carson City*. Charleston, SC: The History Press, 2012.

Laxalt, Robert. *The Basque Hotel*. Reno: University of Nevada Press, 1989.

———. *The Governor's Mansion*. Reno: University of Nevada Press, 1994.

Selected Bibliography

———. *Nevada: A Bicentennial History*. Reno: University of Nevada Press, 1977.

———. *Sweet Promised Land*. New York: Harper & Row, 1957.

———. *Travels with My Royal: A Memoir of the Writing Life*. Reno: University of Nevada Press, 2001.

Makley, Michael J. *The Apprentice Twain*. Woodfords, CA: Eastern Sierra Press, 1993.

———. *Saving Lake Tahoe: An Environmental History of a National Treasure*. Reno: University of Nevada Press, 2014.

———. *A Short History of Lake Tahoe*. Reno: University of Nevada Press, 2011.

Mires, Peter B. "From Great Britain to the Great Basin: Robert Fulstone and Early Carson City." *Nevada Historical Society Quarterly* 41, no. 1 (1998): 40–50.

———. *Lake Tahoe's Rustic Architecture*. Charleston, SC: Arcadia Publishing, 2016.

Moreno, Richard. *A Short History of Carson City*. Reno: University of Nevada Press, 2011.

Nevada Appeal. *Carson City: The Early Years*. Portland, OR: Pediment Publishing, 1997.

———. *A Century of Memories: The Historic Photo Album of Carson City*. Portland, OR: Pediment Publishing, 2000.

———. *Remember When: Celebrating the History of Carson City, 1858–1950*. Portland, OR: Pediment Publishing, 2009.

Nevers, Jo Ann. *Wa She Shu: A Washo Tribal History*. Reno: Inter-Tribal Council of Nevada, 1976.

Nicoletta, Julie. *Buildings of Nevada*. New York, NY: Oxford University Press, 2000.

Nishikawa, Bonnie Boice. *Nevada State Orphans/Children's Home: My Life as a "Home" Kid*. Reno, NV: Carsonstreet Publishing, 2016.

Noy, Gary. *Gold Rush Stories: 49 Tales of Seekers, Scoundrels, Loss, and Luck*. Berkeley, CA: Heyday Books, 2017.

Oldham, Willa. *Carson City: Nevada's Capital City*. Genoa, NV: Desk Top Publishers, 1991.

Riddle, Jennifer E., Sena M. Loyd, Stacy L. Branham and Curt Thomas. *Nevada State Prison*. Charleston, SC: Arcadia Publishing, 2012.

Shepperson, Wilbur S. *Restless Strangers: Nevada's Immigrants and Their Interpreters*. Reno: University of Nevada Press, 1970.

Smith, Raymond M. *Carson City Yesterdays, Vol. 1*. Privately printed, 1999.

Selected Bibliography

Southerland, Cindy. *Cemeteries of Carson City and Carson Valley*. Charleston, SC: Arcadia Publishing, 2010.

Stone, Irving. *Men to Match My Mountains: The Monumental Saga of the Winning of America's Far West*. New York: Doubleday & Company, 1956.

Twain, Mark. *Roughing It*. Hartford, CT: American Publishing Company, 1872.

Williams, George III. *Rosa May: The Search for a Mining Camp Legend*. Dayton, NV: Tree by the River Publishing, 1979.

Wolfe, Ann M., ed. *Tahoe: A Visual History*. New York: Skira Rizzoli Publications, 2015.

Wurm, Ted, and Harre W. Demoro. *The Silver Short Line: A History of the Virginia & Truckee Railroad*. Glendale, CA: Interurban Press, 1983.

Zanjani, Sally. *Devils Will Reign: How Nevada Began*. Reno: University of Nevada Press, 2006.

Zauner, Phyllis. *Carson City, Capital of Nevada: A Pictorial History & Tour Guide*. South Lake Tahoe, CA: Zanel Publications, 1984.

INDEX

A

Ansari, Mary B. 126

B

Bennett, Mary 109
Bliss, Duane L. 26, 109, 128, 133
Blocker, Dan "Hoss" 108
Borda Land and Sheep 141
Browne, J. Ross 56
Buchanan, James 23
Bulette, Julia 39, 44

C

California Gold Rush 18, 20, 21, 35, 50, 70, 95, 118, 127
Carlson, Helen S. 126
Carson and Tahoe Lumber and Fluming Company 26, 28, 29, 30, 128, 133
Carson Appeal 36, 37
Carson, Christopher H. "Kit" 15, 16, 76, 126
Carson City Historic Resources Commission 145
Carson Daily Index 36
Carson Hot Springs 79, 102, 103, 128
Carson Nugget Casino 61
Carson Opera House 61, 62
Carson-Tahoe Hospital 51, 117
Chicago World's Fair 93
Chinatown 9, 12, 18, 35, 36, 37, 38, 45
Chung, Sue Fawn 35, 36
Civic Auditorium 64, 65
Clapp, Hannah K. 90, 91, 92, 93
Clark, Walter Van Tilburg 86
Clemens, Orion 23, 84, 85, 88, 109
Clemens, Samuel Langhorne 23, 83, 84, 88. *See also* Twain, Mark

Index

Cohn, Abe 72
Cohodas, Marvin 72
Comstock, Henry T. "Pancake" 20
Corbett-Fitzsimmons fight 48, 49
Curran, Jack 38, 62, 116
Curry, Abraham 18, 19, 20, 23, 24, 25, 26, 56, 57, 124, 127, 136, 138

D

Daily State Register 80
Datsolalee 70, 71, 72, 73. *See also* Keyser, Louisa
Donner Party 15
Doten, Alfred 106, 107
Drew, Stephen E. 114

E

Eagle Ranch 18

F

Farmer, Guy 108
Ferris, George W.G., Jr. 90, 92, 95
Francaviglia, Richard V. 124
Frémont, John C. 15, 76
French Hotel 9, 86
Friend, Charles W. 90, 95, 96, 97
Fulstone, Robert 77, 78, 79, 80, 81, 82

G

Gardner Ranch 140
Goe, Rusty 58

Gold Canyon 20
Gold Hill, Nevada 21, 23, 79, 113
Governor's Mansion 9, 88, 108, 109, 140
Green, Benjamin F. 18
Greene, Lorne 108

H

Hannaman, Ronni 116
Hickson, Howard 57
Hyde, Orson 17

J

Jack's Bar 26, 39, 40
James, Susan 39
Jones, Janet 109

K

Keyser, Louisa 70, 71, 72, 73. *See also* Datsolalee
King, Benjamin L. 18
Kit Carson Trail 10, 11, 92, 126

L

Landon, Michael "Little Joe" 108
Las Vegas, Nevada 23
Laxalt, Robert 79, 86, 87, 88, 89, 134, 137, 141
Lincoln, Abraham 12, 23, 83, 106, 120
Lincoln Highway 118, 120, 121, 122
Lompa Ranch 140, 141

Index

Lone Mountain Cemetery 26, 44, 62, 77, 82, 86, 109, 115
Lord, Eliot 103

M

Maisel, Eric 83
Makley, Michael J. 131
May, Rosa 44
Meder, John P. 62
Monk, Hank 62, 63, 64
Monmonier, Mark 96
Moreno, Richard 10, 26, 50, 75, 116, 131, 137, 140
Morley, Michael 145
Mormon 17, 18, 20, 23, 78
Mormon Station 17
Mother Lode 17, 35
Musser, John J. 18, 126

N

National Register of Historic Places 31, 65, 113, 140
Nevada Appeal 48, 108, 116
Nevada Bureau of Mines and Geology 104
Nevada Day Parade 106, 107, 108, 135
Nevada Department of Transportation 80
Nevada Museum of Art 72
Nevada Seismological Laboratory 101
Nevada State Historic Preservation Office 145
Nevada State Journal 137
Nevada State Museum 55, 58, 70, 80, 146

Nevada State Orphans Home 136, 137
Nevada State Prison 25, 27, 57, 58, 102, 128, 138, 139, 140
Nevada State Railroad Museum 104, 113, 116
Nevada State Weather Service 96
Nevers, Jo Ann 70
Nevers-Winters Ranch 141
Nicoletta, Julie 113
Nishikawa, Bonnie Boice 136, 137
Nye, James W. 23, 24, 83

O

Oldham, Willa 42

P

Piper's Opera House 60, 61
Pony Express 118, 119, 120
Proctor, Francis M. 18, 20, 126

R

Raycraft Ranch 141
Reno, Nevada 23, 48, 58, 65, 72, 86, 88, 92, 96, 101, 102, 105, 107, 113, 115, 117, 120, 135, 145
Roberts, Pernell 108
Rocha, Guy 39, 126
Rose, Jacob 18

INDEX

S

San Francisco, California 22, 35, 37, 55, 56, 58, 70, 83, 84, 106, 120, 122, 131, 134
Sharon, William 113
Shepperson, Wilbur S. 36
Sierra Seminary 90, 92
Silver City, Nevada 23
Steamboat Hot Springs 102
Steinbeck, John 83
Stewart Indian School 70, 72, 74, 75, 76
Stewart, William M. 72, 74, 95, 127
Stone, Irving 15
St. Peter's Episcopal Church 62, 142
Sutter's Fort 15
Sutter's Mill 17, 21

T

Territorial Enterprise 28, 84, 101, 102
Treadway, Aaron D. 45, 48
Treadway Park 48, 50, 51
Twain, Mark 61, 77, 83, 84, 85, 89, 102, 119. *See also* Clemens, Samuel Langhorne

U

U.S. Geological Survey 101
U.S. Mint 26, 55, 56, 57, 58, 59, 115, 120, 122, 146, 147
Utah Territory 17, 78, 90, 128

V

Virginia City, Nevada 9, 21, 23, 28, 36, 39, 44, 50, 60, 61, 70, 79, 84, 106, 107, 113, 114, 136
Virginia & Truckee Railroad 9, 10, 26, 29, 37, 48, 50, 62, 113, 114, 115, 116, 117, 145

W

Wally's Hot Springs 102
Warm Springs Hotel 20, 21, 23, 25, 138
Watkins, Carleton E. 28
Wells Fargo Bank 55
Whittell, George, Jr. 133
Williams, George III 44
Winters Ranch 48
Woon, Basil D. 137
Wright, William 28

Y

Yerington, Henry M. 115
Young, Brigham 17

Z

Zanjani, Sally 23

ABOUT THE AUTHOR

Peter B. Mires, a native of the Green Mountain State, first came out west in 1990 and has been fascinated with Carson City and neighboring Lake Tahoe ever since. He received his doctorate in historical geography from Louisiana State University in 1988 and subsequently taught at the University of Minnesota–Duluth and the University of Delaware. His publications include two previous books—*Bayou Built: The Legacy of Louisiana's Historic Architecture* (2010) and *Lake Tahoe's Rustic Architecture* (2016)—and more than fifty scholarly articles, book reviews and op-ed pieces. Dr. Mires is retired and lives in Carson City, and when not reading or writing, he may be found hiking the Tahoe Rim Trail or exploring the Nevada outback.

Visit us at
www.historypress.com